P9-CKS-110

YOU GOTTA GET BIGGER DREAMS

WITHDRAWN

YOU

MY LIFE

GOTTA GET

IN STORIES

BIGGER

AND

DREAMS

PICTURES

Alan Cumming

RIZZOLI
NEW YORK

New York Paris London Milan

FOR GRANT SHAFFER.
I GOT THE BIGGEST DREAM.

Grant and Jerry, home, 2015.

STORIES

TO THE LEFT, TO THE LEFT

WHEN I WAS about ten I was cutting the grass outside our house when a car drew up and a strange man got out and asked me if I knew an Alan Cumming.

"I . . . um, I, well . . . ," I stuttered, worried I had done something wrong and this man was from the local gulag and I was about to be abducted and whisked off to some child labor camp. Then I realized that would actually be preferable to my life as it was under my father's draconian regime so I said boldly, "Yes, I am he."

Except I said it too quickly and it came out as "Yamahee," like the name on the side of the plastic electric organ with the wobbly leg my auntie had recently bequeathed to me.

"What did you say, son?" said the man, a slight note of pity in his voice, as though I was impaired in some way.

"I am Alan Cumming," I said.

Years later I saw the movie *Spartacus* and so wished there had been a horde of other little boys amid the freshly mown lawn to echo my childhood pronouncement.

"Then congratulations!" said the man, a smile breaking across his wrinkly face like an accordian opening for air. "You've won a camera!"

He proferred a gleaming plastic box with a plastic Kodak camera inside it along with a packet of Kodak film wrapped in plastic! I was overwhelmed. I'd never won anything before. I thought it must be a joke of some kind. Nice things like this didn't happen to me. I panicked that it was some sort of test my father had engineered to see how I would react.

"But how?" I spluttered, looking at the magical package in my grass-stained hands.

"You went to the Monikie church jamboree, did you not?" said the man, enjoying my puzzlement.

"Yes."

"And you bought a ticket for the *tombola*, did you not?"

"Uh-huh," I countered, my mind whirring.

Suddenly he was a prosecution attorney circling in on the accused, about to look up at the judge and murmur, "No further questions." But instead, in real life, he said . . .

"There you go then! You won this camera! Happy snapping!"

And with that he stepped back into his car and was gone.

I stood there, just staring at the magical offering, absolutely dumbstruck. Suddenly I heard the sound of the front door open behind me and my father was striding down the drive, the tacks on the bottom of his boots beating a militaristic and ever-loudening cacophony that rung in my ears and overwhelmed my present wonder.

"Who was that?" My father's voice snapped me back to reality.

"I won a camera," I said, realizing how ridiculous that sentence would sound to him. Even in something as simple as cutting the acres of grass around our house, his ditzy, flighty son had failed—and not only failed, but *conjured* a camera and some ridiculous story to validate his failure.

My father eyed me suspiciously and pulled the camera from my clutches.

"A man from the church jamboree brought it. I won!" I added faintly.

"If you fell out of a window, you'd fall up," my dad scoffed, pushing my prize back into my hands, turning on his heels, and marching back inside. "Get on with that grass," he threw over his shoulder as he went.

I looked down at the box again. The whole thing seemed magically unreal. This wasn't just a raffle prize, it was something untouchably mine, something my dad couldn't control or beat me at. In an instant I realized what it was to be an artist. I had the means to express myself and now I merely had to work out what I wanted to say.

The first picture I took was of my granny when she came to visit the next week. She was as excited as I was about my stroke of luck and gamely became my first model, posing in front of the rose trellis in our garden.

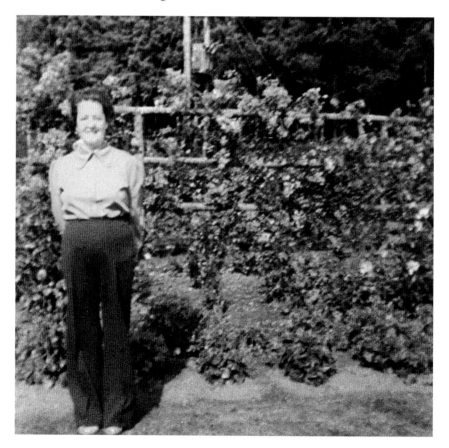

I didn't mean Granny to be so on the left of frame. I thought I was centering her, but my novice skills forbade such a predictable action. However, I am glad she is at the side, beaming away encouragingly, giving the roses a chance to bloom beside her.

My parents were standing by as I took the picture and I felt it rude not to ask them to be my next muses. In the ensuing portrait my framing issues were less able to be explained away, although perhaps cutting my father out of the picture was a rather symbolic premonition.

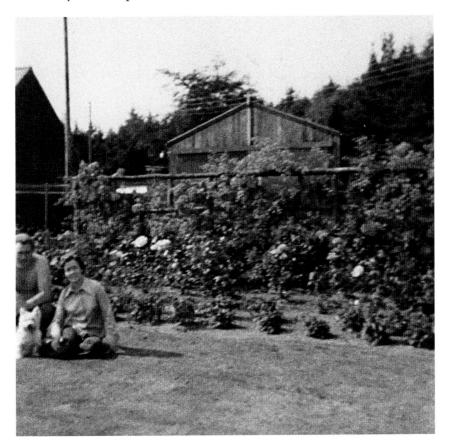

The last picture I am going to show you from that first, and sadly, only roll of Kodak film, is of a sheep and her lambs that were residing in the field in front of our house. Much as I want to advocate the rustic beauty of dry stone walls, I did not intend to show such an expanse at the expense of my ovine models.

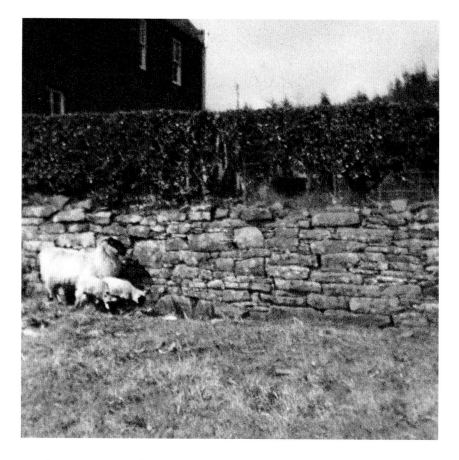

Do you see a theme emerging?!

When that first roll had been developed and picked up from the local town's chemist, and my family huddled around me as I opened the packet and viewed my attempts at captur-

ing my contemporary existence, this photo of the sheep was the final straw for my father. That I had bothered to take a photo of them at all incensed him but it was my repeated left-side framing of my subjects that his militaristic mind just couldn't handle. That, along with the expense of the film processing, made him issue an edict that forbade me from ever taking another picture with my new camera. I placed it in the chest of drawers in my bedroom, and once in a while I'd look at it waiting for me, still sparkling and new, both of us knowing that one day I would be free to tell stories and take pictures of whatever I chose.

That time would come, although by then my little plastic Kodak wasn't the conduit. But its spirit still surrounds me— and now you, dear reader, because . . . guess what?

THE TIME IS NOW!!!!

LUSTROUS PINNACLE

I WAS LEAVING Julius's bar in the West Village of New York City the night after Elizabeth Taylor died and I saw this copy of the *New York Times* lying on a table among the empty beer bottles. I just snapped it.

Every month there is a party at Julius's called Mattachine, which John Cameron Mitchell throws. It's full of fun, counterculturey, queer people—the kind of night I think Liz would have loved.

Everyone was talking about her that evening. Above all, it felt as though we'd lost an ally, a really long-term and loyal ally.

I met her once in LA. I was invited to Carrie Fisher's birthday party and was uncharacteristically early. Like, really early. I was the first to arrive. Next was Liz.

She was helped in by her driver, and she plopped down in a comfy seat in the entrance hall, I presume so she could have a good look at everyone as they arrived. I was hovering nearby, totally awestruck. I introduced myself and we made some banal small talk about the weather and such, and then I totally clammed up. There was an embarrassing pause. She started to

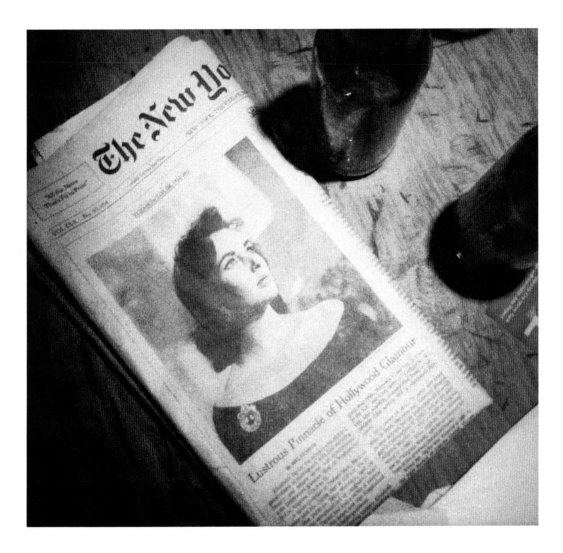

shuffle things around in her handbag and I excused myself and went into one of the main rooms and asked the barman for a stiff drink.

Suddenly Carrie appeared. She'd been running around doing hostessy finishing touches, expecting her one-time stepmother to be kept entertained by yours truly, so when she saw me she wasted no time in chastising me for reneging on my duties.

"What are you doing here?" she asked like a disappointed schoolma'am. "Do you know how many homosexuals would like to be in your position right now?"

I opened my mouth to speak but before I could utter a syllable, she continued, "Get back in there and flank that legend!"

And so I did.

I grabbed my drink and walked back into the hall and blurted out, like the errant ingrate I was, "Elizabeth, I am here to flank you!" She let loose the first of many cackles, patted the cushion next to her, and I sat down beside her.

We began to chitchat. She told me she had recently fallen and I asked her the circumstances. Apparently she had been eating dinner at home and stood up to leave the table but, having left something, made to sit down again to retrieve it. Not realizing her maid had already pulled away the chair, she fell to the ground and injured herself.

"Was there much pain?" I asked in concern.

The screen siren looked straight at me for a moment then rolled her violet eyes back into her head, took in a breath, and clutched one bejeweled hand to her chest. She grabbed my hand with her other, as though she were reliving the pain of the fall at that very moment. It was riveting.

There was silence for a few seconds. She opened her eyes and stared at me, her face a blank mask. She was still clutching my hand and I wasn't sure if I should release myself from her

grip. I suppose I wasn't sure if the performance was over or not. It wasn't.

"Alan," she growled like the Cat on the Hot Tin Roof she still was. "You have never seen such a black ass."

My mouth gaped open in an involuntary gasp. I waited just a beat longer, then with the most saucy twinkle in my eye I had ever mustered, threw down my slam dunk. "Oh, Elizabeth," I said. "I bet I have!"

Suddenly her hand unlocked from mine and slapped me across the chest. She cackled like a trucker who'd just heard a good fart joke.

We got on like a house on fire after that. Pretty soon she was showing me her bling. She proffered her hand with the enormous Krupp Diamond ring Richard Burton had given her in 1968. I told her I had seen smaller New York apartments. Another cackle.

"Can I touch it?" I asked, mesmerized.

"Just don't leave your fingerprints on it," she quipped.

"I could leave my whole handprint on that thing," I retorted.

Soon the party began to fill up, and as people came over to pay their respects to the legend, I felt it was time to vacate my cushion next to her.

"Elizabeth," I whispered in her ear. "I'm de-flanking now."

"All right, darling," she said. "Be careful."

CROCS

I AM FASCINATED by Crocs. Not just the shoes themselves, but more the way, somehow, society has deemed it okay for everyone to think, and then voice openly, that they are ugly.

I suppose I worry about the sheeplike following of any belief. Religion and politics, to name but two, are topics to which people have fierce allegiances that they will unflinchingly defend, yet often these don't stand up to much scrutiny, if indeed much scrutiny is ever entertained. Crocs are much the same.

You need only drop the very name in some quarters and people will spew virulent hatred. I find it frightening. I think it's a form of fascism. We all feel comfortable in our collective hatred of the other. But in this case it's about colorful rubber shoes. Come on, people.

Once I was in Hawaii making the film *The Tempest*. I wore my Crocs all the time because they are comfortable and you can go in and out of the water with them, and I like them. I really, really like them. I like that they are big and clumpy and fun and bold and therefore the antithesis of what we are

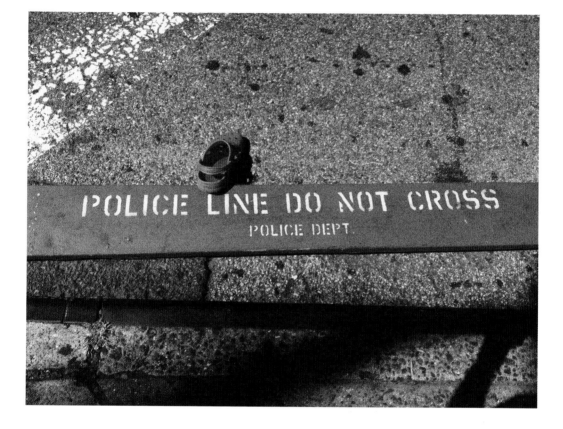

conditioned to believe we should wear on our feet, especially when we are a middle-aged man.

Whenever we went to a new location for the film, we would be given a blessing ceremony. The cast and crew would all gather to watch the Kahu ask the spirits to wish us well and then we'd have a few beers. One night I was chatting to Helen Mirren, who was playing Prospera (it's normally "Prospero" but they made her a woman in our version) and out of nowhere she looked down toward my feet and said, "I think Crocs are really ugly."

I was slightly taken aback. "Oh," I said. "Well, you know what, Helen? Sometimes I think what people are wearing is ugly but I just use my inside voice."

She thought about that for a moment and then replied, "Yes, I see what you mean. But I still think they're ugly."

"Okay," I said. "Let's move on, shall we?"

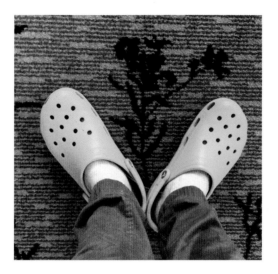

A FEW WEEKS later I was returning for my first day back on set after a break home in New York City. I was driven through a vast forest of short, windswept trees and finally we came out onto a remote, volcanic wasteland. There were the familiar trailers and the hustle and bustle that is a film set gearing up for the day.

As I got out of the car, I heard a familiar voice call my name. It was Helen. She came running around the corner of the makeup truck to greet me.

"Look, Alan, look!" she cried. She pointed down to her feet and to a pair of bright pink Crocs!

"Helen!" I laughed. "You've come over to the other side!"

"Yes," she said, like a little girl who had just been given a puppy. "I was wearing flip-flops but my feet got so sore on all the rocks and so I tried on some Crocs and they're so comfortable and now I've got three different pairs!"

"You were a hater and now you're a lover," said I, happy that I had one more convert, not just to colorful rubber shoes, but to freedom and tolerance and fun!

View from behind

ACTOR **Alan Cumming** had an interesting perspective from the front row at the G-Star Raw show Saturday when a female model with a fantastically shaped bottom, showed off to full effect by tiny hotpants, breezed past. Cumming, sitting next to **Jared Leto**, tried to take a photo of her posterior with his iPhone before he and Leto burst out laughing. He told us afterward in the Mercedes-Benz lounge: "Her bottom was amazing. I tried to take a photo with my phone, but I slipped and took a photo of my shoes instead." *[For more on the G-Star Raw show, and all the latest fashion buzz, see Pages 38-40.]*

TRAVELS WITH HONEY

IN 2004, I left New York for many months to film a movie in Australia. My dog, Honey, had to stay behind in Manhattan and was not best pleased. She had recently become the child of a broken home and had been shuttled back and forth between my ex and me until custody issues were resolved. Then, just as we were settling into a new apartment, a new dog run, a new routine, I disappeared off down under. Poor Honey must have felt very insecure. Indeed, when I was away, I heard reports of a very disturbing trend in her behavior . . .

Jen, my assistant (aka dog nanny) at the time, had gone to the pet shop to stock up on canine nosh and as she was paying, she felt Honey tugging on her leash, very anxious to leave the store. As soon as they were outside on the sidewalk, Jen realized why: Honey had a large swirly bull's penis in her mouth! She had begun to shoplift!

For those of you not initiated in bull's penises, I should tell you that dogs love them. I have never met a dog who would not drop everything and happily spend an entire afternoon chomping on one. To mix my animal metaphors, bull's penises are catnip for dogs. Of course I am sure bulls and cows are crazy for them too, but that's another story for another time.

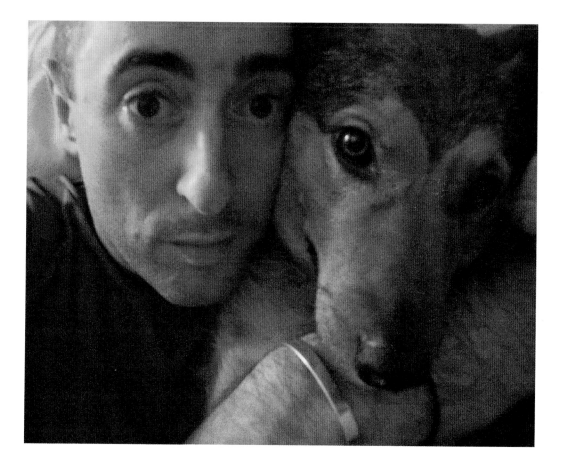

What I really found fascinating about this little insight into Honey's adolescent bout of acting out is how clever she was to know she should remove herself from the scene of the crime, and quickly!

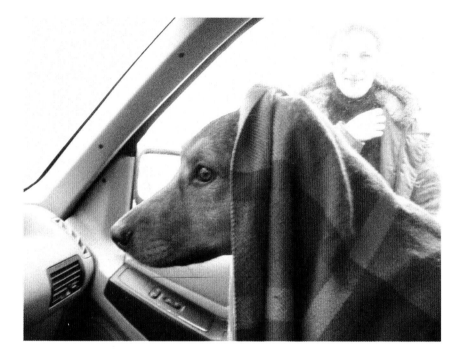

Anyway, I eventually returned to Manhattan and she gradually forgave me for abandoning her in a sumptuous Chelsea apartment, with only Daddy's assistant and a revolving door of beloved friends to keep her company. Soon after though, I was due to start a new movie in Vancouver. I intended to take her with me, but I knew there was no way I could possibly put her in a crate and then in the hold of a plane to be transported all the way to British Columbia. Oh no. Honey was too delicate. We both were. We'd been through a lot this past year. But then

I thought of a solution that would both solve any air-travel anxiety and give us maximum daddy-daughter rebonding time.

Alan and Honey's trans-American road trip!!

This was 2004. Road trips then still involved maps and books rather than Google and Siri. So I bought a guide to doggy-friendly hotels and another that listed cafés catering to vegetarians, and we were off!

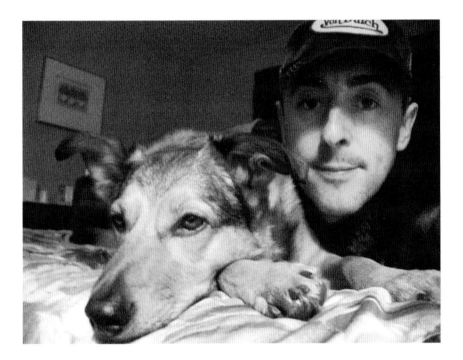

SUNDAY

HONEY AND I left New York City first thing in the morning, and over 550 miles later we were snuggling up together in the Quality Hotel in Toledo.

When the man at the desk asked me why I was in Toledo, I felt it was too weird to tell him I wanted to see the place mentioned in the first line of the Kenny Rogers hit "Lucille," so instead I lied and told him I was driving to Vancouver (which was true) and that it was purely by chance I stopped off there (the lie).

Suddenly the man was fascinated. He couldn't believe I was driving all the way to Vancouver, and said that because of my pioneer spirit he was going to give me a twenty-dollar discount on my room, taking it down to the princely sum of thirty-nine dollars!!! The drinks were on us!

Honey, however, was not impressed. The last hotel she had stayed in was the Chateau Marmont in Hollywood, and though this place was an incredible bargain for thirty-nine dollars—they had free doughnuts and coffee in the morning!! There was a huge pool!!—the Chateau it was not. Honey had been in a bit of a huff all day already, what with having to sit in the car for hours, so coming to a less-than-five-star hotel with not so much as a welcome Pup-Peroni from the manager did not go down well.

That first day I discovered something strange about America: the cups get bigger the farther into the middle you get. I stopped in Pennsylvania somewhere and asked for a small coffee and was handed something the size of a bucket.

And just to be doubly sure there was no danger of my falling asleep at the wheel, I bought a couple of packets of a product called something like "Trucker's Delight," which is basically legal speed, so if I got the slightest bit drowsy I'd pop one of those and all was fine . . . In fact, all was FIIIIINNNNNEEEEE!

Honey and I were in four states that first day: New York, New Jersey, Pennsylvania, and Ohio. And as we were in the Midwest, I decided to try and blend in wardrobe-wise, and I think it worked (see photo on previous page).

MONDAY

OKAY, this day was intense. First of all the security man from the hotel in Toledo accosted me when I took Honey out for her morning constitutional and told me that the nice man who gave us the discount the night before shouldn't have even let us stay at all because dogs were, strictly speaking, not allowed. I told him that I didn't know what to say to that because I had checked in *with a dog* and was welcomed AND the hotel was also listed in my *Traveling with Your Pet* book. He made out that the man from the night before was some sort of weirdy maverick dog fancier who must be stopped.

Luckily he went away, but then later, as we were checking out, he was coming back into the hotel through the glass doors and—karmically—pulled the door the wrong way and caught his fingers somehow (I think there may have been a broken fingernail, it was *that* serious). Of course, he was a big butch security man who prided himself on cleansing the hotel of errant dogs so he pretended nothing had happened, even when I made a point of saying, "That looks really sore, are you all right?"

As Honey and I walked to the car I thought to myself, "I almost wish I believed in God because that would make me feel that He was looking over me right now." However, I do believe in karma and that what you give out you get back and your energy on the surface affects your energies inside and all that stuff, so it was very reaffirming even without the God thing.

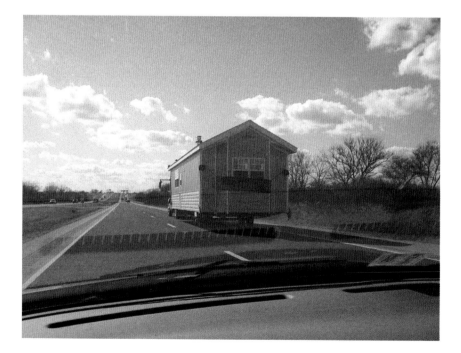

But talking of God, oh my GOD!! Have you ever wondered where on earth all those right-wing religious nuts who seem to be so powerful in America come from?!

I thought I would try and tune in both literally and metaphorically to what middle America was thinking, so I listened to a lot of radio stations that day. First of all, who knew there could be so many rock songs about Jesus?! I am still in awe of the number of things that actually rhyme with the Lord's name: seize us / needs us / freed us / beer nuts (I made the last one up) BUT nothing prepared me for the number of religious *talk* radio shows. It was really discombobulating to tune into something that had the tone of a *Saturday Night Live* sketch, but with zero of the wit.

But what a lesson to hear things from a different perspective. For the first time I became aware of the term "pro-life." (Remember it was 2004.) I had no idea that people were really annoyed at being called "anti-abortionists" by the liberal press (oh, and by the way, the press in America is all liberal), when in fact they wanted—and want—to be called "pro-life." It reminded me of so many other ways the right are better at branding than we are, and we're supposed to be the arty clever ones who trick people with our insidious messages! "The Clean Air Act," for example. "No Child Left Behind." Both of these sound really positive and good for mankind, when actually they're only good for rich people's pockets, especially rich people with shares in fossil fuel companies. And there must be quite a few youngish adults still puzzling how they came to be the ones who missed the bus and were left behind after George W.'s oxymoronic education plan was implemented.

The radio hosts also talked a lot about the gay marriage debate, which, thankfully, no longer exists. It's not that homophobia and bigotry no longer exist, of course—they're still booming—but

everything we had been fighting for in 2004 and those people on the radio had been fighting against is now the law of the land, and, as with many human rights issues, eventually people stop protesting when they see it is not going to mean the end of civilization as they know it and they quiet down until they find some other issue that incurs their ire.

The biggest shock for me back then, listening to those men, was that they were genuinely hurt to be called anti-gay just because they didn't support gay marriage. They seemed to want me to believe that they weren't anti-gay at all (each to his own, etc., though just don't broadcast it, and don't go near any children). They just thought marriage should be a man/woman thing, that's all. And you know what? If that's what you truly think, I'm fine with it. I don't actually think the most important thing is for gay people to be able to marry in exactly the same way a man and a woman can. Frankly, I don't think gay people should be so keen to ape a tradition that is so unsuccessful on a pandemic scale. BUT what I do think is important is that gay people be able to register their relationships legally and get the same rights and benefits for their families and partners that straight people do. And while we're doing that we may as well have a great big party, so let's call it a marriage and shut up, okay?

Another man kept blabbing on about separating church and state, and I remember thinking, "Good luck with that." One of the biggest cons America has so willingly worked on itself is the whole "separation of church and state" myth. It is brought up as one of the greatest and most hallowed of American political tenets. What a load of rubbish!

Every single speech any politician of note in this country makes ends with the phrase "God Bless America!" If he or she failed to do that, there would be an outcry. How could there be a more blatant example of the failure to separate church and

state? If Nicola Sturgeon, the first minister of Scotland, or the UK prime minister were to end a speech with a reference to God, there would be an outcry. But for the opposite reason. It would not be tolerated. *That* is separation of church and state. Wake up, America, you've been duped! God is all up in your grill everywhere you go. America's "separation of church and state" is the biggest con job in history, and we're all buying it, proud of something that doesn't exist, and at the same time we're propagating this myth!

(And also whose God are they referring to? One of the many enlightened deities whom this melting pot of a country of beautiful immigrants struggle to have the freedom to worship and love? NO, of course not. They mean the Christian God, the white one who speaks English and shops at Brooks Brothers. It's ridiculous.)

Another great American discovery I made that same day was that Denny's restaurants had wireless Internet access! It's funny to imagine now, when you can get Wi-Fi even in a park, but that trip then held many challenges in getting online and staying in contact with my real life, and boy, as you can imagine, sometimes I really needed it. Denny's restaurants' Wi-Fi cost a whopping fifteen cents a minute, but the very fact that they had it at all I saw as a mark of progress. That, and a religious, right-wing talk show host getting annoyed he might be misconstrued as being anti-gay. God Bless America!

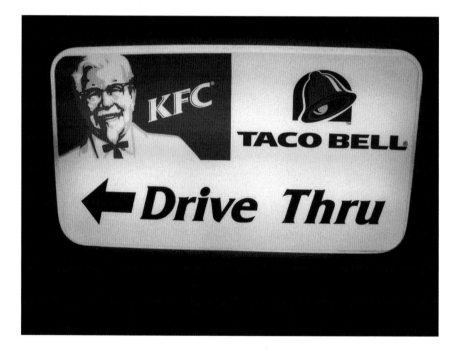

Talking of blessings, later that day I found the perfect US combo: a KFC–Taco Bell drive-through! With my outsider's eye I have realized that these fast-food places tend to cater

specifically for the catchment areas they are located in. For example, a few years ago McDonald's tested the McVeggie burger only in their downtown Manhattan outlets. Alas, and also hooray, it was never heard of again. Therefore, guess what the KFC–Taco Bell outlet in Newton, Iowa, had to offer a vegetarian? Mashed potatoes, baked beans, and coleslaw. And the baked beans had bits of meat in them.

By the end of Monday we had driven another 550 miles through the states of Ohio, Indiana, Illinois, and now Iowa.

We checked in, exhausted, to the Des Moines hotel that the singer Tiny Tim had lived in for thirty years, and where Elvis had spent a night in too!

TUESDAY

AS YOU can see from the pictures on the following pages, Honey immersed herself in the local indigenous culture. I was always so in awe of her for that. As we drove deeper and deeper into the Wild West, leaving Iowa and passing through Nebraska and South Dakota, she successfully managed to shed her sophisticated downtown Manhattan mutt identity and exude the demeanor of a dirty old prairie dog.

In the morning we went for a brisk walk around downtown Des Moines. The Des Moinians are very proud of their skywalk, which links lots of downtown shops and restaurants together, presumably so you can consume more and not get cold. We didn't go in it (as a protest against capitalism) but, along with my partisan stance on this matter, I have two things that I think are wrong about the Des Moines skywalk as an outside observer:

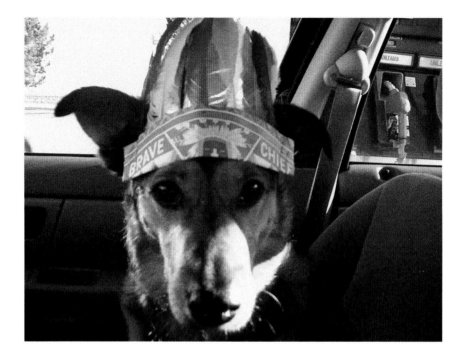

1) It is not a skywalk. It is on the second level of the buildings. So "skywalk," strictly speaking, is a capitalist lie.

2) The fact that everyone walks in it instead of on the sidewalks has killed street culture in Des Moines. We walked for about half an hour on the street and we only saw one lady, and she couldn't hear me say hello because she had headphones on!!

I had had enough of the radio. There was one channel that seemed dedicated to scaring people. Seriously, there were no records or commercials, just a series of dull men warning us about the perils of being alive. My favorite one was about crime on vacation. They advised me to call ahead to my chosen vacation spot and inquire which area was the most crime-ridden so then when I did actually go on vacation, I should avoid said area. Brilliant!

Honestly, now I understand why so many people have guns in this country. Every time you turn on the radio in these parts you encounter a barrage of insidious auto-suggestive messages encouraging you to buy one. Also, can anyone tell me why I kept seeing so many signs for fireworks outlets? Is it just that I was driving so far that, by law of averages, I must pass quite a few? But come on, in all my years of driving all over the world, I don't think I have ever seen a sign for a fireworks outlet other than in the United States. Do people in the Midwest let off a lot of fireworks? Are fireworks outlets euphemisms for gun shops?

After I turned off the radio I got my iPod out and with the benefit of my iTrip I was able to listen to all my fave tunes. Nowadays, the iTrip seems as antiquated as the Sony Walkman or an eight track, but back in '04 it was really cut-

ting edge. I remember thinking, "The technology we take for granted!" Later that evening in my hotel room I would plug my computer into the hotel's phone system and, using a special local number from a list I'd been given when I called up my Internet server, I was able to plug my computer into my hotel room's phone and eventually communicate with friends all over the world, and only have to wait a couple of hours for my pictures to upload!!

That night Honey and I found ourselves in the Thunderbird Lodge in Mitchell, South Dakota. It was very nice, but the reason Mitchell lured me was the promise of its much-vaunted Corn Palace. It would have to be good to beat the giant cows and the medium-size dinosaurs that we'd seen outside various hostelries en route, or indeed our own Thunderbird Lodge's rather weird rabbit with one antler that Honey is posing in front of in the picture on the following page.

WEDNESDAY

THAT MORNING we were up and at it at the crack. The lady at the hotel gave me a map and I knew I was in the vicinity of the Corn Palace when I saw hundreds of old and infirm people being helped off buses. Old people make up the bulk of the palace's visitors, apparently. This was confirmed by the plethora of articles in the gift shop with mottos like "If We Knew Grandchildren Were This Much Fun We'd Have Had Them First" inscribed on them.

And there it was. The Mitchell Corn Palace. I have to say it was pretty impressive. At first one of the elderly men in caps outside wouldn't let me in because of Honey being nonhuman. He

said she might upset the animals inside the building. I thought he might be slightly confused but, as it transpired, the Corn Palace was an entertainment center and there was a circus going on inside it (think Madison Square Garden covered entirely in random vegetables and you get the hang of things). But then another, nicer man in a cap said I could go in with Honey and if anyone asked me about her I should pretend to be blind. Luckily, nobody did, though I'm sure I could have pulled it off.

We pushed our way through the walkers and took a look. It was fascinating. In the 1890s the few citizens who had settled there tried to think how they could lure more people to Mitchell, and the idea to cover an entire building in corn came to mind. And it worked! People were so intrigued they came in droves and Mitchell is now, well, Mitchell.

Also they re-cover the palace every year with new corn, and they had pictures of every single year on the wall. Honey and I looked long and hard but couldn't really tell the difference.

After days and days of flatness we hit the hills. And I was gobsmacked by the beauty of them. First of all the Badlands. Wow!! Superwow!

As we were approaching the Badlands I needed gas so we came off the highway and found a tiny little hamlet with a gas station and this insane building. It was like the set of a western, but it was for real. Just as I took the picture a man with a hoe came running toward me saying he wanted to take a pic-

ture of me. I didn't want a picture of me—there are, frankly, too many of them in the world as it is and I told him so—but he was very persistent and the hoe was featuring heavily as he gesticulated and I thought to myself, "This is like one of those awful *Jeepers Creepers* movies and before I know what's happening I'm going to be skinned and tanned and covering the walls of his basement." So Honey and I hurried back toward the car.

He was still some way off but I walked briskly and started the engine and locked the doors. He still didn't give up and was actually running alongside me for a few seconds as I turned onto the track toward the road to the highway. Phew! He probably just wanted to earn a dollar for taking my picture, but hey, hadn't he ever heard of public relations?!

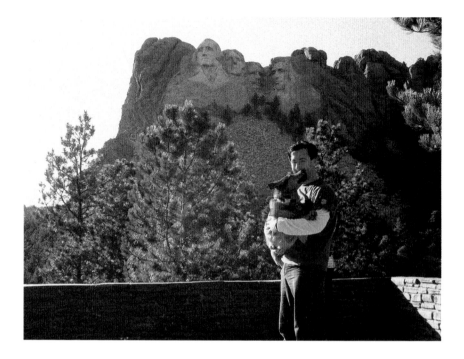

Crazy Horse was fab. It will be even nicer when it's finished. And Mount Rushmore was great too. Honey and I walked along the Presidential Trail and took it all in.

Did you know that Roosevelt is wearing glasses? You can only see the rims as, obviously, if they'd done the whole spectacles you wouldn't see his eyes. So the rims give a *suggestion* of specs. Then we drove for miles and miles through the national park and saw buffaloes and deer and funny things with horns. It really was an amazing day. Honey had walked more that day than she had done all week and collapsed onto the bed as soon as we checked into our room at the Holiday Inn Express in Spearfish. We were *still* in South Dakota!! I wish I'd had more time there because there were tons of tacky

things to do advertised for hundreds of miles all along the highway, like petrified gardens and insect farms and an 1880 village that was in *Dances with Wolves* and a place where you could pet prairie dogs. I should point out I have not, nor never will have, any desire to pet a prairie dog, but I'd quite like to watch others do so. There was also a shop called Wall Drugs that had me so intrigued. I heart South Dakota.

Except that night, when we were looking for a hotel. We had stopped off in Deadwood (you know how I love a town that has been a song lyric) and a couple of the hotel people were unnecessarily bitchy about Honey, I thought. I hadn't really liked the vibe in the town anyway. All the hotels and bars had slot machines at the front of them. I think it had something to

45

do with Deadwood being near the border of Wyoming, where they don't allow gambling, so Deadwood has become a sort of mini Las Vegas. Actually a poverty-stricken, unglamorous Las Vegas with people who are bitchy about dogs. You see, money had corrupted them. But then we went to Spearfish, where there were no slot machines, and met another bitchy man so that theory doesn't really hold up. Finally we discovered the very welcoming Holiday Inn Express! Honey and I were so excited to stay in a hotel that had ROOM SERVICE, but then crushed to discover the room service had closed down that night at 7:00 p.m., as there were only twelve rooms filled in the entire building. So we ordered in, and—guess what—the options in that neighborhood were slim. I have never longed for the arrival of a Domino's pizza so much in my entire life.

THURSDAY

THE ROCKIES!! Wow!! We finally left South Dakota, crossed through Wyoming, and entered Montana, where we bunked down for the night in the Blue Sky Motel in Bozeman.

I liked Bozeman. It had a nice feel. There are restaurants that look like they serve veggie things. (I became a little tired on the trip of asking if there was anything on a menu that wasn't meat and hearing "chicken" as the reply.) Also I loved that Bozeman is surrounded by big hills. I realized that day that I love hills. I crave them. I think that's what I missed most when I moved to London from Glasgow—the hills. And after days and days of flat it was so nice to be among hills. I

47

think hills are great because there is always something new or unexpected or different to look forward to on the other side of them.

I had such a desire for there to be a Starbucks in Bozeman, which, in 2004, was one of the few places offering the magical luxury of connecting online wirelessly. The Holiday Inn charged me an arm and a leg for the local calls I had made to go online the night before (also, it was mega slow). So that, as well as the notion of buying a cup of coffee that was not too heavy to carry back to my car, sparked my desire for Starbucks. I didn't find one though.

I honestly think the mark of a great hotel, one with dignity, is that they offer free Internet access. I mean, come on, it costs them hardly anything, and they often charge exorbitant fees for

it. I would rather pay a little extra on my room charge than have to piddle around with my credit card or tick loads of boxes just to get online once I've checked in. I think it's ironic that the most expensive hotel we stayed in on our journey was the only one to charge us by the minute for local calls! But here we were in luck, because the Blue Sky Motel offered free local calls!!

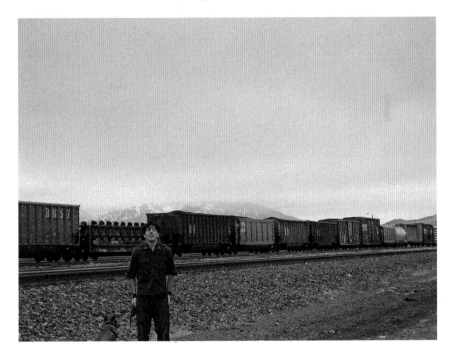

Back on the road, I foolishly listened to one of those right-wing talk shows again, and the man was spouting forth about how foreigners can't comprehend diplomacy and all they under-stand is the "iron fist" (whatever that actually means). President Bush had signed into law the Unborn Victims of Violence Act that day, which had engendered a lot of chat about when exactly we become a person and worthy of legal protection. The man on the radio believed it was the second the sperm fertilized the

egg, which is pretty early on by anyone's standard. I began to muse that soon we would be told that masturbation was a crime against an unborn child, and we might have swarms of sperm police scouring the South arresting bemused young adolescents as they innocently pleasured themselves. Of course, it would no longer be called "pleasuring." It would become "denial of the unborn child's existence" or "recreational birth waste."

The man on the radio, though, was more concerned with John Kerry, the Democratic presidential candidate at the time. Kerry, who had apparently missed 78 percent of Senate votes that year because of his campaign, had flown back to Washington especially to vote against this bill, and how could anyone vote for a man who condones violence against unborn children? The whole argument seemed to me so insane and a semantic minefield and just stupid, and it really got me down that people were listening to this and presumably agreeing with it. So I turned over to good old NPR, which I had abandoned earlier because they were having one of their fundraising drives, and Casey Flintoff had actually done an impersonation of Winston Churchill. I didn't get the connection unless, unbeknownst to me, Churchill also took to the airwaves to recruit supporters by boring them into submission. There is truly nothing more annoying than those swotty NPR types trying to convince us what a good conversationalist Terry Gross is! We know, we know! She is amazing! (Although, sidenote, the last time I was on, Terry did spend an inordinate amount of time talking about my sexuality and then my armpits—it had felt as though if I squinted, the NPR acronym had morphed into TMZ.)

Anyway, I went back to NPR to discover I was listening to the local station in Laramie, Wyoming, and I thought of poor Matthew Shepard, and I wondered which radio station the people who killed him listened to.

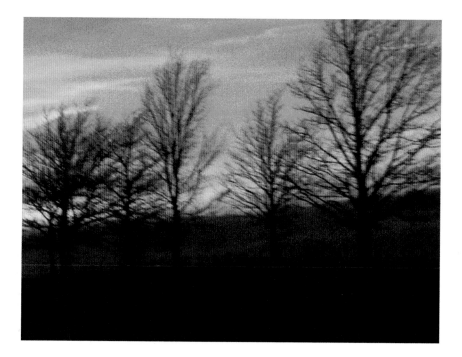

It turned really cold that night, after driving all day in my tank top. It even snowed. I snuggled up with Honey and prepared for the journey to Washington, the last American state of my odyssey.

FRIDAY/SATURDAY

WELL, we did it! As Blanche DuBoise said, "I can smell the sea air!" Honey and I had gone from sea to shining sea! We had traversed a continent!

We decided to drive straight through to Seattle on our last night and, as you can see, we were both really happy to see my then boyfriend, Rob.

More radio doublespeak: The United Nations is corrupt. That is why we (the United States) had to go into Iraq and pick up the slack. And now that US civilians were being hung and burned, it was the UN to blame. Duh.

I have always thought that a really big problem in America is the inability to accept or seek other points of view, especially at that point in 2004, when there was so much anti-US feeling in the world. So it was all the more galling to hear xenophobia being openly encouraged.

Maybe that's why we just decided to drive on and not spend another night in a hotel en route. I think the lovely Rob and hippie, lefty Seattle were what Honey and I needed.

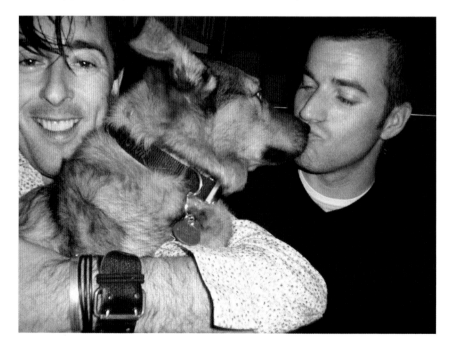

Okay, so I know this picture of Honey lounging on board Rob's houseboat is enchanting but I feel I have to report a bit of bad Honey behavior: I bought a bag of pork rinds in South Dakota and was giving her one or two at a time to quell her appetite on the long drive. I kept the bag under the driver's seat of the car. Then, at a service station, when I returned after pumping gas, I discovered Honey sitting on the floor amid a sea of pork rind crumbs, her nose jammed into the corner of the bag, the sachet of salsa that came with the rinds the only thing that had not been snaffled. (She wasn't big on salsa.) The look of guilt on her face was palpable. And this, remember, after her flagrant theft of a bull's penis from an NYC pet shop a few months ago. I was pretty worried by this trend, but then I remembered it was well past her dinnertime

and she had been trapped in a car for an entire week, so one little misdemeanor wasn't too bad, I suppose. But still . . .

Saturday was a whole day without driving! My shoulders were very happy. The next day we were to leave the good ol' USA and head for our final destination, Vancouver.

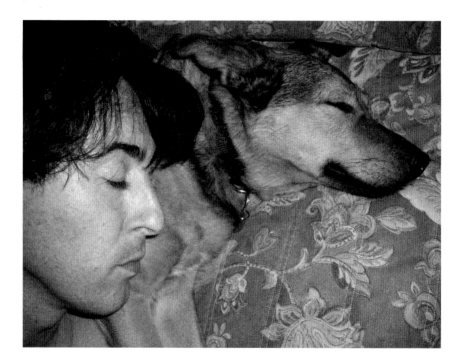

SUNDAY

AFTER MORE than three thousand miles Honey and I were at the end of our travels. We arrived in Vancouver, unpacked, and settled into a suite on the fifteenth floor of a downtown hotel. The next day I was to begin work on *Reefer Madness*, the movie musical.

Maybe it was the thin air up there that made us both so sleepy, or maybe it was the three thousand miles. We had ended our odyssey. But where we arrived was less important than where it had taken *us*. We were back together again, man and dog united in our adventures traversing life.

At the end of *Reefer Madness*, Honey and I drove back home together, across Canada this time, in a 1978 Volkswagen Westfalia camper van named Herb that I'd bought impulsively from a lady on Vancouver Island. It was to be our last transcontinental road trip together, as shortly after we got back something happened that ensured Honey would always be able to stay at home with her dad, even when I went off to some foreign clime. Well, when I say something, I mean, of course, someone . . .

GRANT

GRANT IS MY husband and I love these pictures of him because it reminds me of when I first fell in love with him.

He wasn't wet, of course, but you get my point.

I took these at a lake near Niagara Falls, on a road trip in our since-deceased Volkswagen camper van. We were actually en route to the Toronto International Film Festival, where I had two movies opening. Later that evening we stopped at a campsite and cooked our dinner on an open fire, and it was one of the loveliest nights I can remember.

Honey, though, wasn't so keen. She was not an outdoorsy kind of girl and kept begging to be let back inside the van as we sat around the fire, looking at the stars. In the middle of the night we heard bears rustling about outside the van so Honey probably had the right idea.

The next evening I was smiling and waving on the red carpet, a far cry from the unkempt camper covered in ash and bug spray of the night before.

But back to the point. These pictures are as close a visual representation I can muster to describe how it felt when Grant arrived in my (and Honey's) life, with his kind eyes and his rocking bod, in a blaze of blinding sparkles, like the angel he is.

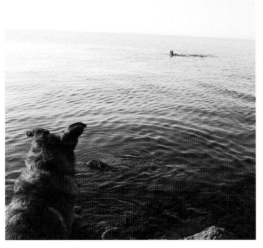

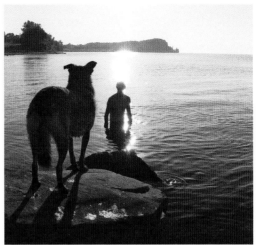

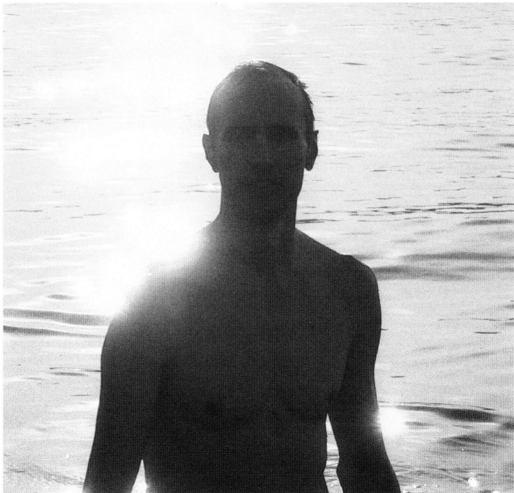

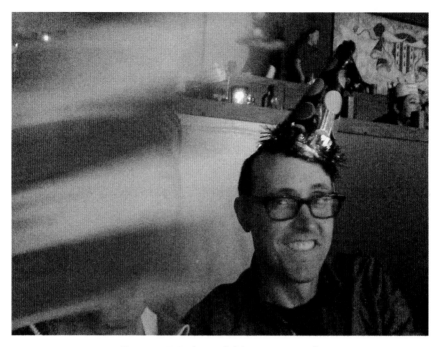

Grant, Medieval Times, 2014.

People often come up to me and think they know me from somewhere. And of course they do, kind of, but they know me from a film or TV or some magazine article. It happens a lot to Grant too. People are always coming up and saying they recognize him. They've never met him, they've most likely never seen a picture of him before, but what I think they are recognizing is kindness in his face. That's why they feel comfortable enough to ask. That's what they feel drawn to. Kindness just exudes from his being.

This picture was taken at my birthday party a few years ago. My friend Eddie and I have birthdays close to each other and often we celebrate together. That particular year we hired a party bus and took a ton of friends to New Jersey, to a magical

place called Medieval Times. It's one of those faux olde worlde knights-and-damsels extravaganzas where you sit in bleachers and drink out of pretend pewter flagons and watch people with very amplified but not very accurate English accents say things like "and now, I kill you!" before trying to knock each other off their horses with jousting sticks. It's great!

I looked over at Grant at one point during the evening, just after, if I remember correctly, the knight our color-coded section had deemed us loyal to had successfully seen off a challenge from an opponent in a rival color. He looked such a geek, but with his party hat on and his beaming smile, he was also like a little boy. And that is why we are such a good match I think. We've both got a little boy close to our surfaces, we're always game for adventure, but we're both grown ups too, ready to support or challenge or catch the other.

Before he knew what was happening I snapped this picture, and it reminds me of the blur of fun that moment was, that indeed my life is now. I lucked out. We both did.

SNOW MAN

IT WAS ONE of those magical nights when the snowfall was
stealthy and huge and I was in a bar and missed the whole
thing. When we stumbled out later and found it, it was as if
someone had done a magic trick, like the whole city was part
of an elaborate illusion and any second David Blaine would
jump out and wave his hankie and everything would be drab
again. I felt like someone on those home-makeover TV shows,
eyes welling with tears at the wondrous beauty of streets that a
few hours before I'd walked along without a second glance. As
we crossed Tompkins Square Park we saw that someone had
already built this snowman.

The reflected light from the streetlamps made the whole
world look sepia or like one of those computer-animated car-
toon films where characters aren't really real, but they're too
real for a drawing. It was weird.

And then the sound. I love the sound after snow. It's all
dense, heavy and light at the same time.

The next morning, when I walked the dogs, he was gone.
But this is the proof I didn't imagine it.

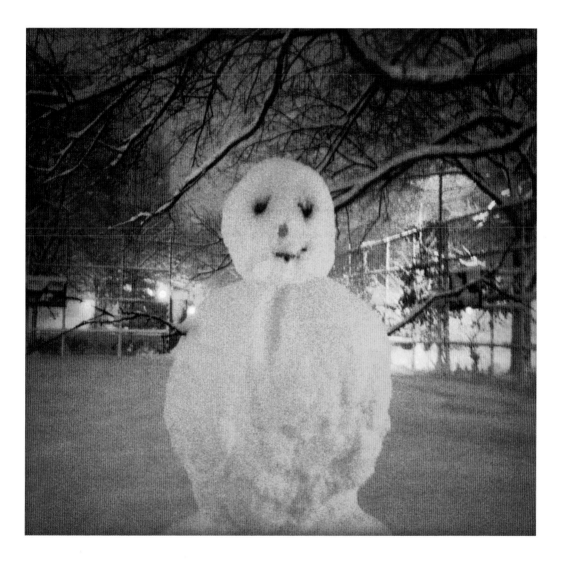

POOL BOY

ALTHOUGH THIS picture looks as though it was taken at some swanky birthday party in the Hamptons or Saint-Tropez, or even on some oligarch's superyacht, it was actually on very dry land, in the swanky splendor of terra firma that is the Four Seasons restaurant in New York City. It's one of those old-school places that old-school people think of as quite modern. There is a big reflection pool in the middle, though it doesn't necessitate the employ of the type of gentleman you see in this picture, and the huge windows are masked by weird metal mesh curtains that sway rather mesmerizingly in a breeze.

My friend Glenda Bailey had invited me to a bash there one evening for her magazine *Harper's Bazaar*, and she was about to make her speech so I was trying to position myself to get a good snap of her at the podium.

Then this boy, who was part of the evening's theme—I suppose you could call it "nautical but nice"—stepped in front of me. Although my view of the stage was now obscured, I made an executive decision not to ask him to move but instead just listened to Glenda and enjoyed the vista of his magnificent and massive corn-fed back.

Glenda understood.

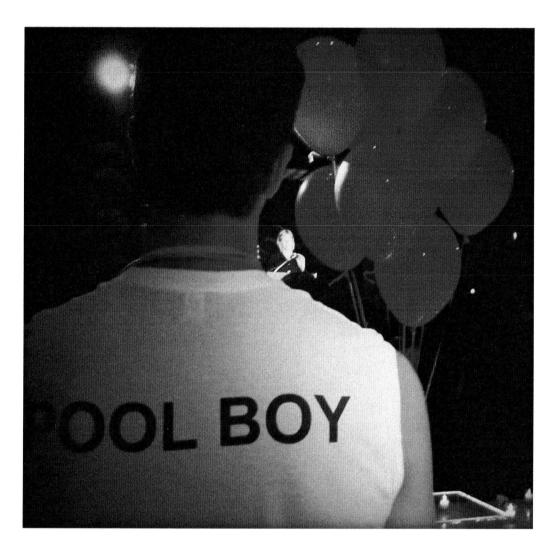

AFTER DARK

I AM a party animal.

I used to think it was just because I was Scottish, and it was part of my cultural identity.

Then I thought I must be so eager to dance and have fun because in some way I was seeking the unadulterated joy I so rarely felt as a child.

I used to think it was a phase and soon I would become one of those people who have things programmed on their DVR and go to bed early and "hit" the gym before work.

Now I think it's just who I am—how I'm wired. I am in touch with my bacchanalian side. I am a sensualist. I understand the need to let go.

Over the years I've seen a few people go too far, though, and lose their balance on that tightrope between thrilling fun and joyless need. Others have just become tired, or older, or attached. I am very lucky in that I am growing older attached to someone who hasn't tired of revelry, but also gives me good counsel when it's time to hit the hay.

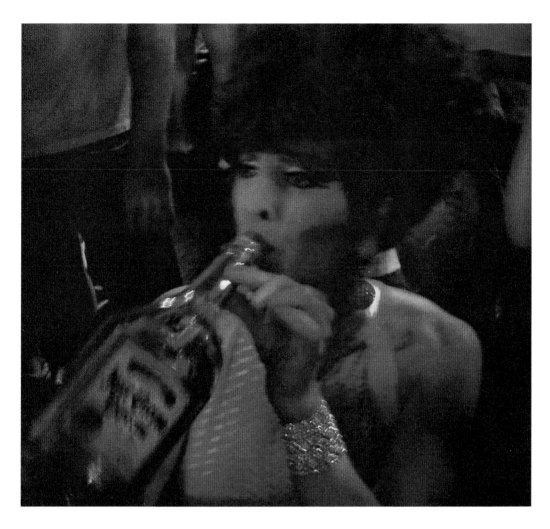

This is my friend Edie. We were at an annual New York City event called *Broadway Bares*, where hundreds of dancers get nearly naked and do incredible routines and then let people stuff money in their underwear and it's all for charity. It's my kind of a night.

It's debauched, it's clever, it's appreciative of beauty and talent, and it's doing good too. Anyway, before the start of the show, there's a ritual of everyone doing a shot of tequila, and I caught Edie slugging one back in her very ladylike manner.

I once arrived at a friend's house in Los Angeles in the early hours of the morning only to find that the Halloween party he was throwing was over. That is sort of a metaphor for my experience of LA. When I first went there in the mid-1990s, I couldn't get to grips with it at all. I had this anxious feeling I was missing the party. But I don't think I was. I think in LA you have to make your own party.

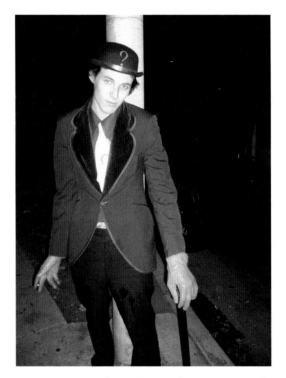

I'd let my taxi go and so I just hung around on the sidewalk watching the rejected revelers pile out onto the street, hoping I would know a sober one of them who could give me a lift back to my hotel. I turned around and there was this boy, totally smashed, wobbling next to me in his amazing outfit, smoking a cigarette. I asked him if I could take his picture and

he simply nodded. I think he was actually incapable of speech. I did so and then some people I knew appeared and when I looked around again for him he was gone.

I am slightly alarmed by the stains on his pants.

I know I sound a little bit down on LA. But when you think about it, it's a city built around an industry with self-consciousness at its very core. Everyone needs to look good, and everyone is looking at how good everyone else is looking. So I understand why that could make letting go in a public place a little more taxing for its denizens. However, there is fun to be had of an evening if you know where to find it.

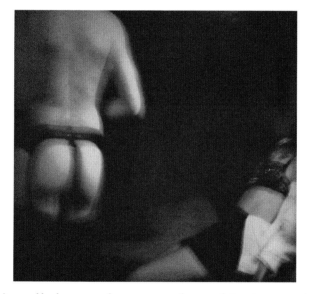

I don't really know what to say about this picture. Anything I say will probably alter the impression already forming of it in your mind and I don't want to interfere with that. Suffice to say nobody was harmed in the capturing of this image. In fact, everyone, including the people watching, was having a very good time.

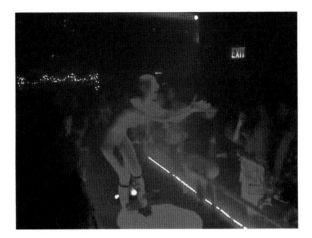

There's an old-school strip joint on the west side of downtown Manhattan called Westway, and on Tuesdays there used to be a really fun gay party there called, naturally, Westgay. Each week there would be some sort of performance on the catwalk that traversed the dance floor, and one evening this androgynous wonder totally captivated me.

As did the go-go boys watching, waiting for their turn to get back to the grind.

The below picture was taken at a party called Rasputin. Of course, because it was Hollywood, the boys in the picture were behind a screen. You can see me reflected in their beauty.

Eastern Bloc is my favorite little dive bar in the whole of NYC. It's also conveniently within stumbling distance of my home. I've had many great nights in it. I even had a fundraiser for Obama's first election campaign there and auctioned off various choice items from the DJ booth, like a Wonder Woman cookie jar donated by Lynda Carter herself, and my parking pass for the ill-fated wedding of my old chum Liza Minnelli and David Gest.

Talking of the DJ booth, it's always my first port of call. This particular night I went to say hello to Darren, one of the owners, and didn't realize I was capturing a moment of tenderness when I took the pic on the following pages.

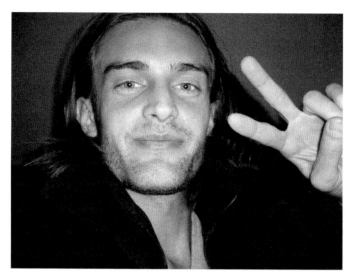

Unknown cute boy somewhere in New York City,
sometime this century.

Once I went to a party that had a candy-floss room!
This girl was not as impressed as I was.

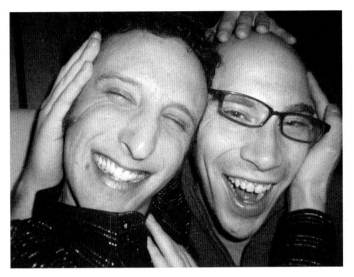

Smith and Chris.

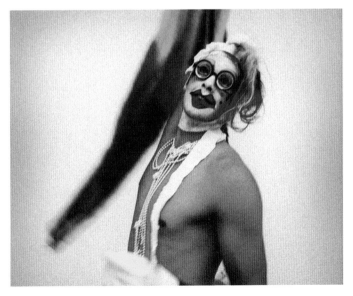

He needs no name.

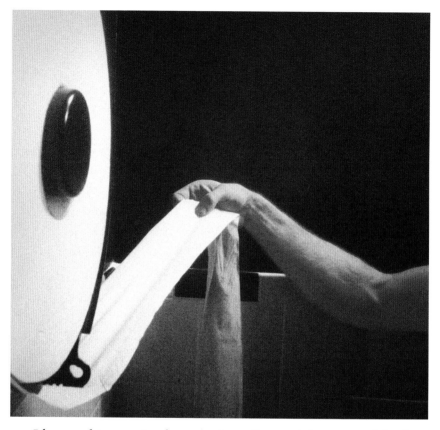

I love waking up in the morning after a night out and finding pictures in my camera like this one.

I've done a lot of impromptu photo shoots in bathrooms.

I suppose I like finding beauty in places that are a bit taboo. I saw a documentary about the *New York Times* photographer Bill Cunningham, and there was a bit when he received the Chevalier de l'ordre des Arts et des Lettres from the Ministry of Culture in France and he said, "He who seeks beauty shall find it." I totally agree.

This is me and a man in some bar who also had a mohawk.
I was playing Mack the Knife in *The Threepenny Opera* at the time,
so I was out every night exorcising the Brecht/Weill demons.

It's amazing what you spy in doorways, minding your own
business walking down the street.

Joan E, an old chum from Vancouver.

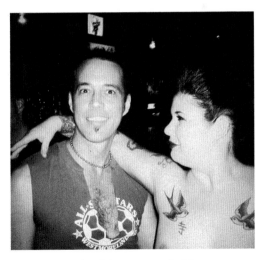

Naked Tony and Clio.

Whitney entertaining the troops.

Diego.

Joey.

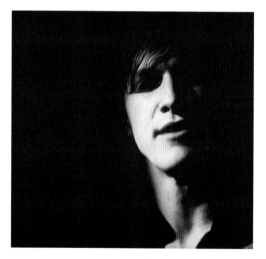

Patrick.

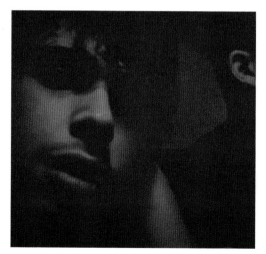

James.

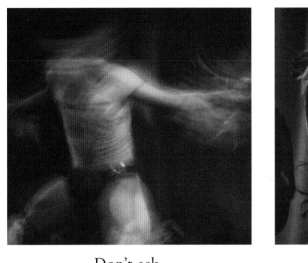

Don't ask.

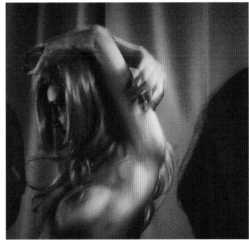

Didn't catch her name.

Nor his.

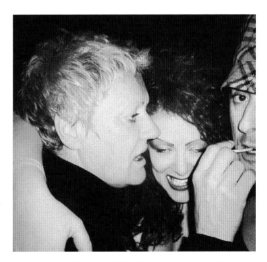

I call her "lolly snatcher."

This was the morning after the night before scene in my
LA hotel room after hosting the Britannia Awards in 2012.

In a hotel room at the Democratic National Convention in Boston, 2004.

Drag queens are heroes . . .
Or heroines.

I tend to be looking down a lot by the end of an evening.

The night my father died.

I would never put these in my body, but I do love a late-night snack stop.

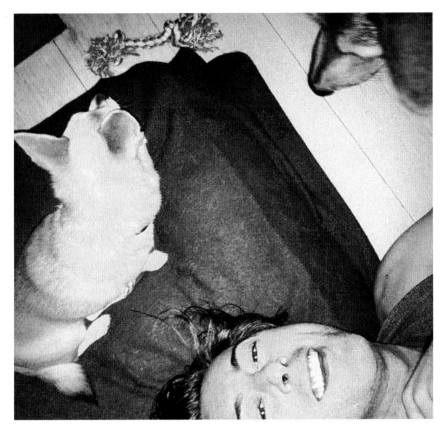

Home.

MURRAY (KING OF THE) HILL

I FIRST LAID eyes on Murray Hill in 1998. I had just arrived in New York City and was devouring the downtown scene like a deprived child.

One Sunday night I was taken to the Spy Bar in Soho. There were little spyglasses upstairs and you could sip a cocktail and sneak peeks of the clientele below. It was like living in New York City in microcosm—the thrill of watching was shared equally with those who knew they were being watched.

The first night I went there I spied Murray. You couldn't miss him. He was standing next to a skinny blonde club princess named Penelope Tuesdae, and he and she were the hosts of the evening. I had never spoken to a drag king before, but Murray didn't fit any of my preconceived notions about what one would be like: he was just a funny guy, sort of like someone I imagined you'd see on TV in America in the 1950s, too knowing and his eye too twinkly for you to completely believe his schtick, but obviously very comfortable with himself. One night Murray and Penelope sang. It was awful, and a star was truly born.

I have been to Murray's shows over the years and have got to know him well. Every time I see him, my face lights up. He's like my favorite uncle, and indeed going to see his shows is like seeing a relative grab the mic at a wedding and refuse

to give it back. You can't believe what he just said or how he just murdered some standard, but you never want him to stop.

Murray embodies the whole downtown club/performance scene for me, not only because we started enjoying it around the same time, but because he is daring and full of abandon and completely devoted to his craft. Yes, that's right, craft. AND he is also a really nice guy. I have taken all sorts of people of all ages and all sexual orientations to Murray's shows and no matter how dirty or out of hand the evening has become, my guests have always been enchanted by this man, his warmth, and his love of life.

JESUS TAKE THE WHEEL

ONE NIGHT I was in my favorite bar in New York City, Eastern Bloc, having a few drinks with friends, when all of a sudden the DJ stopped playing, dry ice started being pumped all around us, and the strains of a song—at the time unfamiliar to me but now firmly lodged in my consciousness—started to blast through the speakers.

Suddenly a sparkly drag queen materialized through the smoke and began to lip-synch to Carrie Underwood's "Jesus, Take the Wheel."

Because the story was so morbid—a young mother with a baby strapped in the backseat of her car loses control on some black ice and decides, instead of trying to right the car or protect herself and her child, that she will leave it up to the Lord to decide her fate—I thought it was a joke, a parody of country music's catchy gloominess. But no.

Then the chorus kicked in and yes, there appeared a girl dressed in a bad wig and beard holding a steering wheel. I give you, from my reality, "Jesus, Take the Wheel" . . .

TRAVIS AND HIS FRIEND

THIS IS ANOTHER picture taken in the bathroom of Julius's bar in New York City's West Village at John Cameron Mitchell's monthly party, Mattachine, named in honor of the Mattachine Society, one of America's earliest gay rights groups.

Travis, in the foreground, and his friend were posing for me, but when I saw this picture afterward I could see something totally genuine and honest in the way his friend was looking up at him. I don't know if they were lovers, but I imagine that the friend would have liked it to be so.

22ND STREET

I TOOK THIS in the apartment I lived in on 22nd Street in New York City in 2003. It was a funny old place: huge, like living in a basketball court, I always thought. The best thing about it was I could exercise my dog, Honey, without having to go outside as she loved to chase me around the perimeter of the enormous living space and the floors were wooden and shiny so she skidded at every corner and we both ran and ran till we were dizzy and hysterical.

Another good thing this flat taught me was that I am not cut out for loft living. I could never get really cozy. I had bought it with someone but we split up and so I moved in alone. But the whole aesthetic and sensibility were not for me. It was all that person's, and living in a house you'd bought for someone who is no longer in your life is not very healthy. I didn't stay there for long.

The upstairs was a little better because it had some actual rooms and a terrace, which I loved, though because I knew I wasn't going to make this my *home* home, I never really committed to the terrace—and as you can see from this picture it became a bit of a dumping ground as I stutteringly unpacked.

Honey loved it, though.

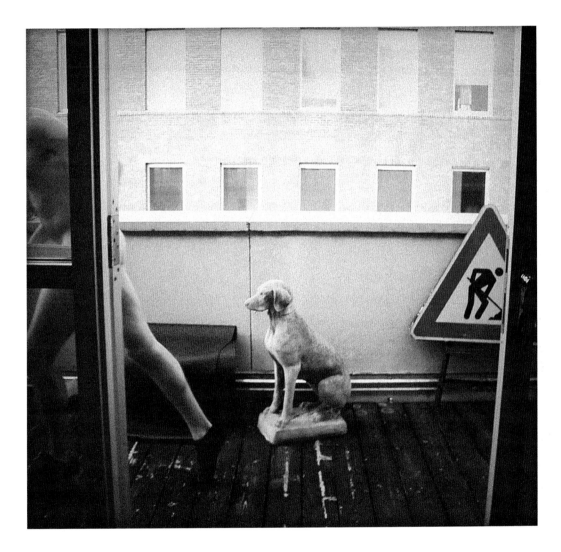

The sign I stole when driving up a mountainside in Tuscany, because I just thought it looked like it was telling us we should beware of men shoveling up poop. And I actually think we should.

The yoga mat was recently washed and drying in the sunshine. It is actually quite a contentious yoga mat, if you can imagine such a thing, for it has emblazoned on it "Fuck Yoga." My friend Barnaby used to have a line of T-shirts and yoga gear and skateboards that all read "Fuck Yoga" and I was the poster boy for the catalogue he had made to sell them. It all caused quite a stir. Some people just thought it was funny and appreciated it in the way it was intended—adding the word "fuck" to the most benign and least-likely activity to arouse expletives was a way of provoking a response and hopefully engendering a discourse about language and humor. But for others, the whole thing really pressed their buttons and they couldn't exactly explain why. I loved it.

Once I was working out in a gym in Vancouver. When I arrived I'd seen a few people whispering about me, something that I am very used to and so I thought little of it. A short time later, as I was puffing away on the pec machine, a young, perfectly formed trainer walked toward me looking a little sheepish.

"I'm sorry to ask you this," he began.

"Of course," I countered, knowing the best way to deal with this situation was to find a pen and a piece of paper, give him the autograph, and let us both move on as quickly and efficiently as possible. But no, that was not what he wanted at all.

"I'm going to have to ask you to leave the gym," he said.

"What?" I spluttered.

"Some of the members are offended by your . . ." He gestured down to me with his muscly hand and for an awful, brief moment I thought my penis was sticking out of my shorts. But

then I realized the cause of his consternation. I was wearing a "Fuck Yoga" tank top.

"My shirt?" I asked incredulously.

"Yes. Many of our members practice yoga," he said solemnly.

"Well, so do I!" I laughed a little, aware now of those I had offended looking over from their little Lululemon huddle. "Look at my body!"

I admit this was a strange and possibly ill-timed admonition but it was true. Had there been a yoga class available there was no way I would have been struggling with these unfamiliar fitness machines.

"Our members don't like yoga being made fun of," the trainer continued.

I looked over his shoulder at my humorless Canadian accusers and shouted, "But it's a joke! It's ironic! I love yoga!"

They turned away, as one. I noticed one of them was wearing white socks that came up to just below his knobbly knees and at that exact moment I knew it was a lost cause. I got up and left.

The person in the picture is Rob, my boyfriend at the time. He was training to run the New York Marathon and had just come back to my flat after a huge, long run up the West Side Highway. He would always be drenched in sweat after a run and want to shower immediately, but first he had to run the gauntlet of me, my ever-curious nose, which loved to explore the olfactory nuances of an active young gentleman, and also my camera. This is as close I got to him that afternoon.

Eventually he did run the marathon and what an eye-opening experience that was—for me, at any rate. First of all it entailed my going on the subway to Brooklyn, *twice in one day*, to cheer him on at various stages of the ordeal. At mile fifteen his friend and co-runner was on the point of collapse and had I not been holding her up she would have fallen to the ground

in an exhausted, sweaty pile. Her younger sister, who was my runner-wife companion for the day, gave her some water and shoved a plastic tube of energy gel into her mouth.

"I'm not a quitter," the elder girl kept mumbling as her knees wobbled like jelly.

"I know you're not, but look, you're not well," I remonstrated, horrified at seeing someone so physically break down in front of my very eyes.

"Come on! You can do it!" shouted a well-wisher from the crowd behind us.

"No, she can't!" I shouted back to them, angrily. "She's practically unconscious!"

"You can do it!" they shrieked, ignoring me.

"Stop fucking encouraging her," I yelled back.

Just then, something changed in her eyes, and I could feel the strength returning to her body. She lifted herself up from my grasp and tottered off into the swaying, sweaty throng. The glucose from the gel pack had kicked in and her brain, if not her body, had told her she was well enough to continue.

The worst part of the marathon was in Harlem, mile twenty-two. I saw Rob turn a corner and hardly recognized him. At mile fifteen, he had bounded past me like a gazelle. Now he looked like an old man. Everything in his body seemed to be shutting down, and indeed it probably was. I was shouting louder and louder to try and get him to hear me, to will away the old man and to encourage the return of the gazelle I had seen earlier, and, frankly, that I wanted to sleep with that night. Finally he heard me as he ran close by and I saw a little flicker of a smile, but it was painful to watch.

Soon after, I was at the finishing line. Mark my words, if you ever think of running a marathon, go to the finishing line of one and just watch the array of battered humanity that strug-

gles across your vision. It will be seared into your mind forever, and you will never want to entertain something so stupid again. I saw people collapsing, vomiting, pooping, crawling, all to the cheers and encouragement of their lunatic friends and family. I felt as though I was at a cult meeting and I was the only one who was not a member. All around me foil blankets flapped in the breeze, covering the beleaguered bodies of those who had just crossed the finish line. I saw them look down proudly at the medal that now hung round their necks, with a mixture of huge pride, disbelief, and utter shock.

Back at the flat I made Rob and his chum lie in baths of ice, as I had done some research and found this was the best thing to do to hasten recovery and prevent injury. Later we had friends over and had a little marathon celebration party. I made a toast, frank both in my admiration for their having achieved such a huge goal but also in my incredulity that intelligent people would want to punish their bodies and threaten their health in such a momentous way. I reminded everyone of the whole reason marathons are run: In 490 BC, a poor bloke named Pheidippides ran from the battle of Marathon to Athens to bring the message that the Persians had been defeated. He ran the entire 26.2 miles without stopping, and when he arrived managed to get out "We have won," then promptly dropped down dead. So marathon running is really a celebration of death.

Which brings me to the stone dog in the picture. People used to think it was meant to represent Honey, and though it looked a bit like her, I'd actually been given it by my mum as a housewarming present when my ex-wife and I moved into a flat in London in the late 1980s. I got it in the divorce and it has stayed with me through many moves, relationships, and homes since. Now, sadly, it does represent Honey. After she died in 2014, we moved this stone dog to her favorite spot on

the deck at our house in the Catskills, where she loved to lie, one eye on the reveling humans around her, the other scanning the meadow below for pesky deer and wild turkey. We had a little memorial for her and put flowers round the stone dog's neck and dropped some of her ashes between its paws. Every time we pull up in the driveway upstate, there it is, gazing out over the meadow from Honey's spot, and so naturally it has now come to *be* Honey.

So I'm glad I've lugged such an unwieldy thing around the world for twenty-five years. And nearby, the Italian "Beware the Poop" sign leans against a wall, and often, nursing a beer and laughing his booming laugh and thankfully no longer running marathons, sits Rob.

And I still do yoga on my "Fuck Yoga" mat.

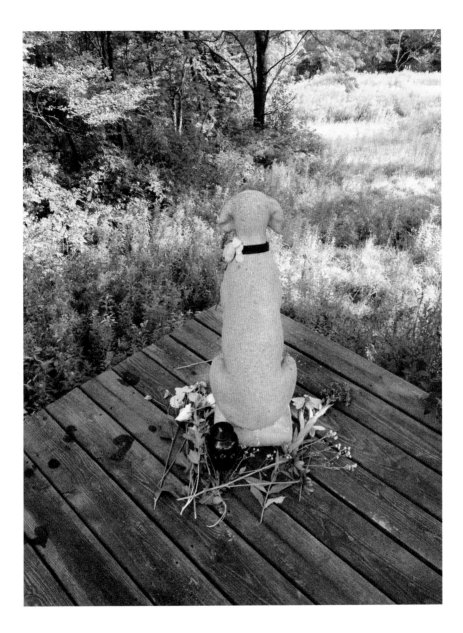

CHEST PEACE

I'M GENERALLY pretty happy with my body but I do wish I had a hairy chest. This fine specimen is not mine, alas.

I'm hairy everywhere else, annoyingly. My legs are forests. My arm hair I sometimes have to trim as it gets a little unruly, and as for my armpits . . . they positively gush with hirsuteness. My butt, my . . . you know, I could go on.

Just not my chest. Well there's a little bit, a sort of weird, straggly copse at my sternum. The rest of my body hair is pretty wavy so this looks like someone has glued on a tuft from some girl's abandoned weave. I once grew so sick of its solitude I shaved it off, only to discover a newfound appreciation as I realized it acted as shading and gave my pecs some much-needed definition.

I am ever hopeful though. I remember when my dad got a hairy chest. He must have been in his late thirties or early forties, and one day I saw him change his shirt and was shocked to see he had sprouted a flurry of down across his upper chest that hadn't been there before. Sadly I'm now fifty and nothing approaching a sprout, a flurry, or down has emerged.

To be honest there have been a few stragglers around my nipples, and on my left pec (as you look down from my vantage point), there is an almost respectable cluster, though as this is not nearly matched on my right side, I mostly shave them off in the interests of symmetry, or lack of.

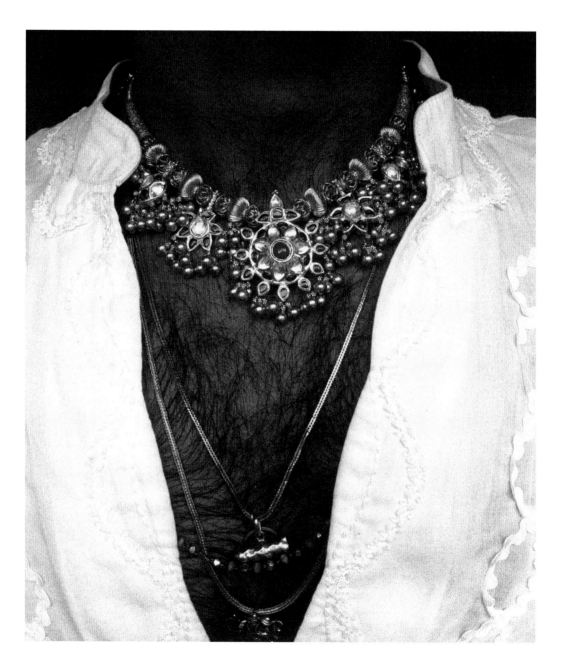

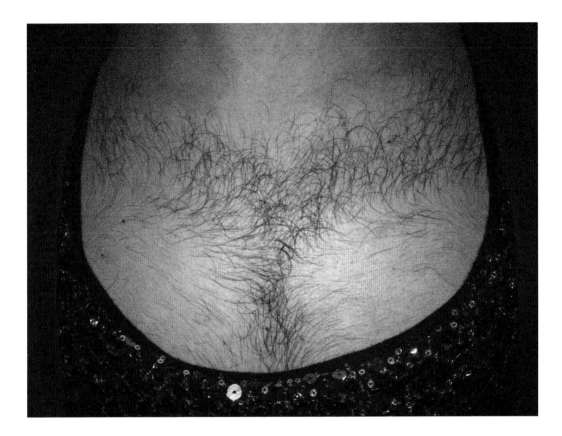

So instead I admire others' chests. Is it because I am so lacking that I enjoy these so much? I've thought long and hard about this. And I think no.

For me, a hairy chest equals Man. Just like a curvy ass and ample tits equal Woman. I like both for the same reasons.

It's just less easy to get snaps of the latter, in public places. Although . . .

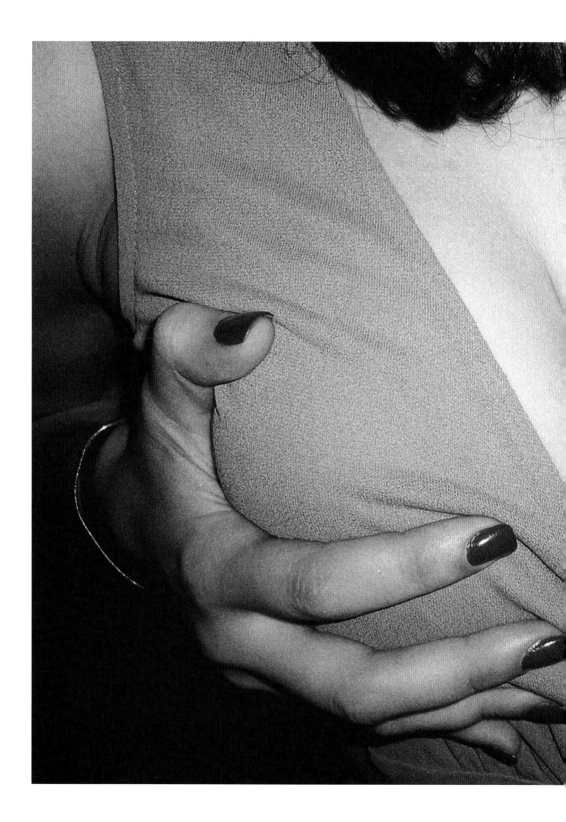

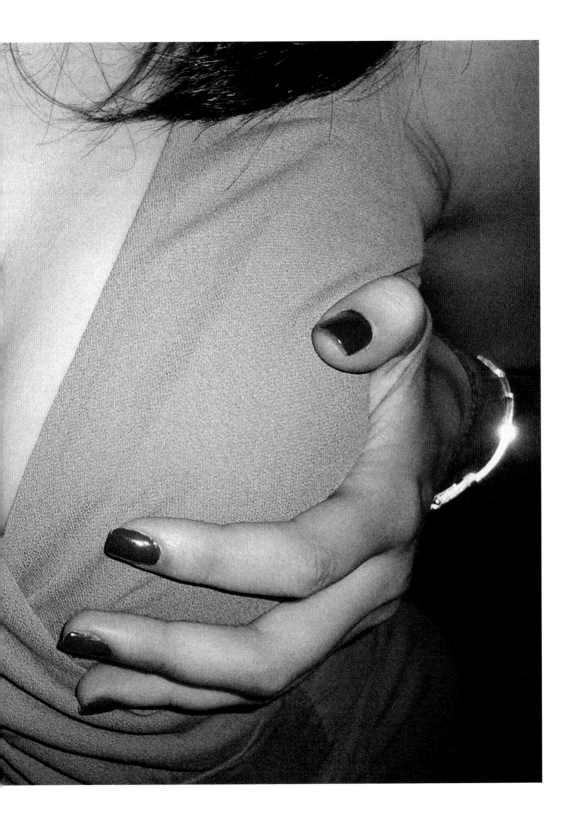

SUMMER KNEE JERK

I LOVE SUMMER in New York. It's so sexy. People wear fewer clothes than normal and, perversely, get closer to other humans than they normally would. This cluster of limbs would never happen in winter. There's something leveling in everyone being semiclad. Fashion is, thankfully, mostly forgotten, and instead respect is given to those who dare to bare. Reveal it and you will feel it.

But it's not just about exhibitionism, although in a vertical city like New York, where we are part of the view much of the time, every act is in a sense exhibitionistic. No, it's more about a practical confidence that comes with wearing less—being comfortable and therefore more open to others.

And desire. Skin and sweat and not caring who just rubbed up against you at the bar, or whose knee yours were pressed up against. It's summer and all bets are off. Enjoy.

GLENN CLOSE'S BACK

A FEW YEARS ago I was walking along the red carpet at the Tonys, as you do, and something happened that, although very common at these types of occasions, might seem rather bizarre to those who do not frequent them . . .

I call it a celebrity crush.

It occurs when too many celebs arrive at once and the TV crews and photographers are overwhelmed with panic at the possibility they are not going to get the regulation sound bites and photographs that are their birthright to accrue.

Of course the whole point of walking any red carpet is to *be* photographed and/or interviewed, but logic has no place in this equation. I think it's because the sheer volume of star power contained in a celebrity crush is sufficient to wipe the minds of every non-celeb present of all reason and induce in them a primal braying sound that I imagine was the last thing the Christians heard just before a very large member of the feline family caused them to shuffle off their mortal coil.

If you are ever on a red carpet, even if there isn't a celebrity crush, you should close your eyes for a minute, and I swear it sounds like you're in a disaster film or on a ship that is sinking— screams of panic abound and yet nearly everyone looks gorgeous.

Anyway, back to the celebrity crush. There isn't much to do when they happen aside from put on a smile in case someone is taking a sneaky shot of you, and wait patiently for your

turn to answer inane questions and scan the horde of paps while pretending both are totally natural things to do.

Of late I have grown a little anarchic and have decided to just do the photos and skip the interviews! Yes, I know! Red Carpet Sacrilege! This first occurred at the Golden Globes where, during my first interview, I was asked to proffer my foot to a "shoecam," and in that instant a voice inside told me it would be unwise to do any more interviews that day. Also, I knew there was a champagne bar at the end of the carpet where I would not only be able to guzzle some free bubbly but an animal rescue charity I had nominated would receive a thousand dollars for my doing so. It was really no contest.

This time at the Tonys though, I passed my time waiting in the celebrity crush by taking photographs, and this one is a particular favorite. It is of Glenn Close's totally smoking ripped back.

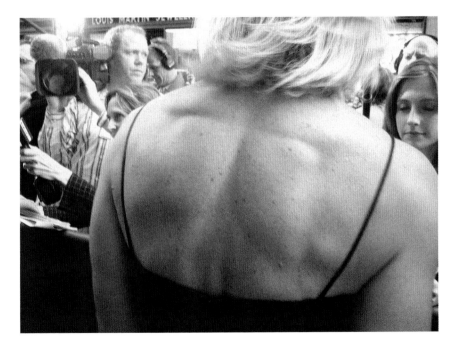

IRIS APFEL'S HAND

ONCE AT A really swanky Fashion Week dinner I was sat next to the legend that is Iris Apfel. Iris had recently turned ninety and was wearing a characteristically colorful and idiosyncratic outfit, but I was most fascinated by her hands, perhaps the only part of her ensemble not to be embellished. Her face was, as usual, dwarfed by her huge round glasses and her little white pixie hairdo was stylishly *deshabille*.

Iris has been a style guru for decades and decades and I was really looking forward to our dinner conversation. She amiably agreed to my taking her photo, and soon we were chatting like old chums.

Shortly, however, a gust of icy wind would blow across our newfound friendship.

We had been talking about young people, and how so many of them nowadays were having to move back in with their parents after finishing college. I started on my spiel about overpopulation and my theory that very soon it would have to become an issue in political discourse. We just cannot sustain this many people on the planet. Not enough jobs for

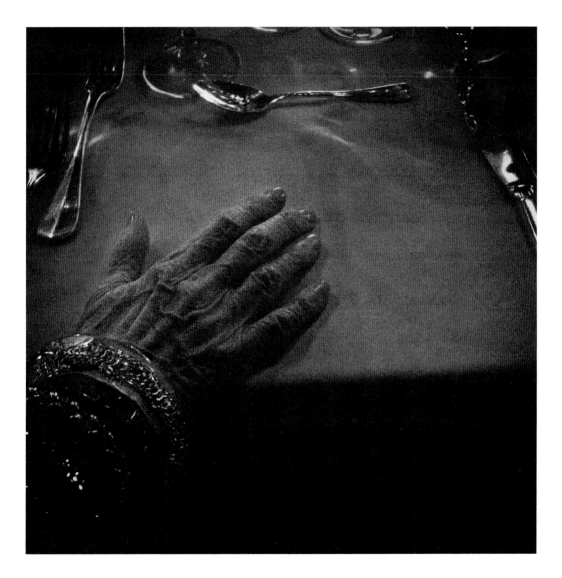

our young, bright, and hopeful being just the tip of the iceberg, in my opinion. Iris had another theory.

"It's all Obama's fault," she said, sourly. "He's done nothing for young people."

Thinking we were just hitting a little road bump in our newfound paldom and not a complete and utter car crash, I replied jovially, "Oh, I don't think that's true, Iris. He's been very good about encouraging young people to stay at school and be educated and helping them financially to get to college. And now with the DREAM Act he's trying to make changes to the immigration system so that young people who were born in this country will be able . . ."

I won't tell you what Iris said next.

Now, I don't know about you, but I have long been guilty of assumption when meeting new people, and by that I mean assuming they think like me, socially and politically. And of course, I am often disappointed. But Iris was one of us, I thought. She was in fashion, she looked like a hippie granny, she was *cool*. Well, all these things are true, but what I did not bargain for was Iris being a rabid Republican. One of the kind that is incapable of an actual conversation when it comes to politics. There is no exchange of ideas. There is merely an opinion, usually at the pretty extreme end of the sensible— and certainly sensitive—spectrum, followed by the hum of metaphorical tinted windows being raised, enabling no further chance for you to reach them or for them to ever question or justify whatever mean, prejudiced belief that has just been expounded. It's the equivalent of a wasp stinging you and then flying away: it has moved on to be bitter and mean in pastures new and you are left frustrated, angry, and wounded.

And then of course came the perennial riposte that adds to the injury: "Let's stop talking about it," said Iris crossly.

"Okay, Iris," I acquiesced.

The good thing is that the picture I took retains the Iris I had imagined before our conversation that evening. The kooky, weathered, and beautiful creation that she undoubtedly is.

BODY PARTS

BUT NOW, in honor of Iris's hand, here are pictures of other body parts that have caught my eyes over the years.

And I'm going to assume they're all lefties. Actually some of them I know are for sure, because they're me.

A barman at a party in the Hollywood Hills, 2011.

Honey and me, at home, 2014.

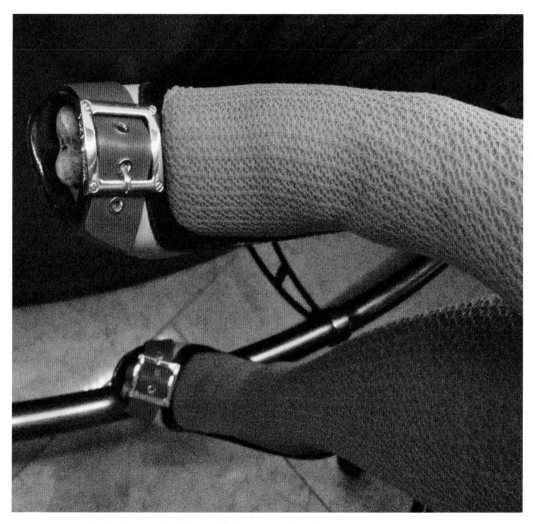

A lady in the bar of the Ritz Carlton, Boston, 2012.

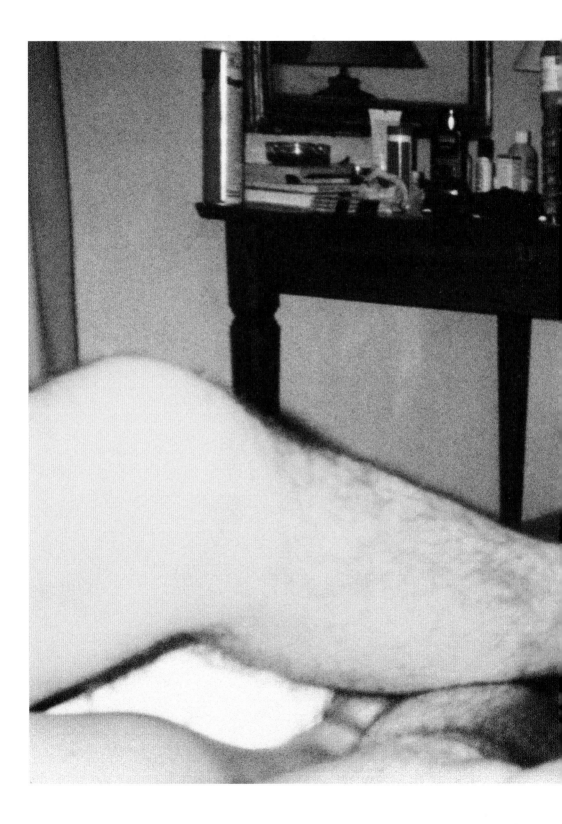

Andrew, Sue, and me in a hotel room somewhere between Toulouse and St. Tropez, 1997.

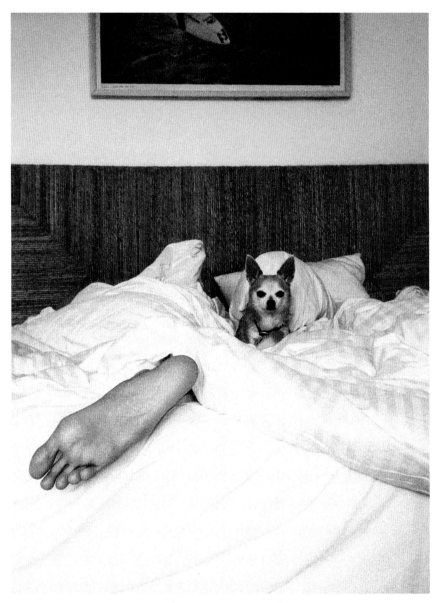

Grant and Leon, Montauk, 2012.

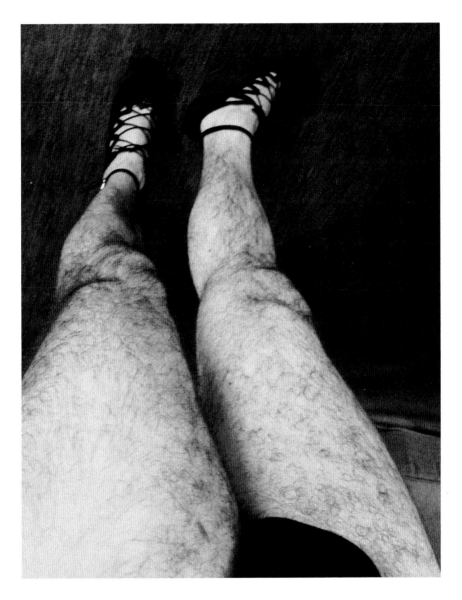

My legs, *Cabaret* costume fitting, 2014.

Me, backstage at *Cabaret*, 2014.

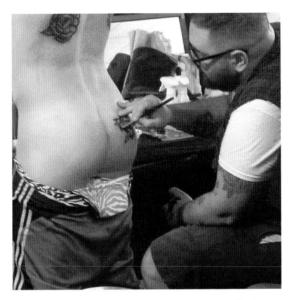

Backstage at Broadway Bares, New York City, 2014.

A burn on a waiter's arm, New York City, 2012.

A barman at Flaming Saddles,
New York City, 2014.

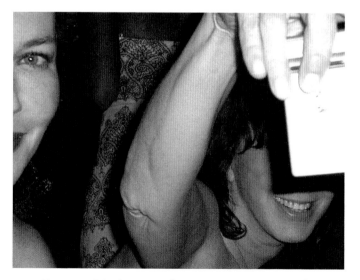

Connie Nielson and Donna Karan at the
CFDA after-party, New York City, 2005.

Me and Rob, Skye, 2003.

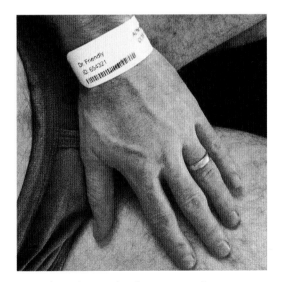

My hand just before a performance
of *Macbeth* on Broadway, 2013.

Mike Furey at Don Hill's, New York City, 2011.

Me doing an impersonation of Danny Burstein,
Cabaret, New York City, 2014.

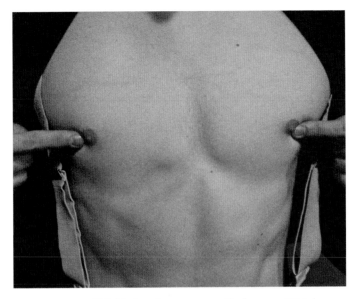

Will, backstage at *Cabaret*, 2014.

Unknown boy, unknown location,
sometime this century.

Reed, New York City, 2011.

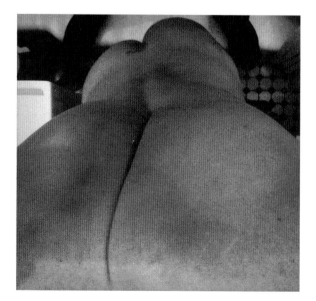

Jared in Sammy Jo's bathroom, New York City, 2012.

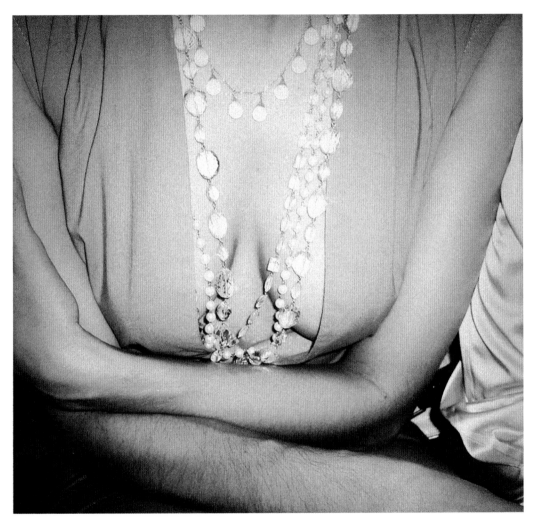

Eva Mendes' boobs, Roosevelt Hotel, Los Angeles, 2005.

FLESHBOT

IN 2011, *Fleshbot*, the sex blog, decided to give me their Sexy Fashion Award, for I suppose my sexy fashion choices, but also for my sex positivity, particularly in the campaign for my fragrance line, *Cumming*.

Yes, I had a fragrance and it was called *Cumming,* and I was shot re-creating various iconic fragrance advertisements of the past and I got naked for the commercial and lolled around in a bed with eyeliner on and talked about shame not being sexy. If you really want to know, I also had a body lotion called *Cumming All Over*, a body scrub called *Cumming Off Buff,* and a body wash called *Cumming Clean.* But my particular favorite was the soap—*Cumming in a Bar.* Thank you.

(I actually have a second fragrance that is still available and it's called . . . can you guess? *2nd Cumming*!)

Now, I love an awards show at the best of times, but one that celebrates sexuality and sex positivity is even more up my alley. The first thing that delighted me on arrival at the Fleshbot awards was the goodie bag. First of all it was waiting for you on your chair. You didn't have to do that embarrassing

walk by twinky interns clutching handfuls of them as you left the event and silently exhort them to hand one over. It was already there! And in it there was a Fleshlight!!!

For those of you not in the know, a Fleshlight is a masturbation device. It's that black thing on the left of the picture. You unscrew the lid at the bottom of it and you discover a latex interpretation of a vagina, an anus, or indeed, as my extensive research for writing this story has uncovered, a mouth. Mine though, was a beautiful pink vagina. You then lube up and insert your penis into the Fleshlight and you experience a very lifelike (some even say better-than-lifelike but I think they need to get out more) re-creation of what it feels like to be penetrating another human. You then pull the Fleshlight up and down and, well . . . I'm sure you get it.

I had wanted a Fleshlight forever, and now here it was, free in a goodie bag! I think it rated as my top awards show swag ever, perhaps equal first with an orthopedic bed I once got from the Emmys. And as you can see, they also very kindly included some condoms and lube, and that gleaming silver dildo is the actual award!

For many reasons, this was a night of firsts. I had never been at an awards show that ended with some of the presenters showing their genitalia before (well, not in public at least). I had never seen my name engraved on a dildo before. And I had never received an award that I could potentially penetrate myself with, safely at least.

Many years ago when I lived in London, my friend Richard introduced me to a game called "knobbing the bronze." It was a very English public-schoolboy, repressed-sexuality sort of a wheeze, but nonetheless quite fun. What happened was, if you won an award (the "bronze"), you had to, as soon as was decently possible, hit it with your penis (the knobbing

part, see?). That was basically it. I remember once wearing a kilt when I won a big theater award and was able to knob my bronze before I even got back to my seat. But then as the evening wore on, and drinks were imbibed, the game became more daring. You had to go and ask various famous people if they would knob your bronze too, and you'd be surprised how many acquiesced.

The thing about having a sex toy as your bronze to begin with though, is that there is no need to knob it. It is inherently already knobbed.

My Fleshbot has pride of place among my awards stash, and it gets handled by the curious *way* much more than any of the others.

I AM WRITING THIS BECAUSE
GORE VIDAL TOLD ME TO

———

I TOOK THIS picture backstage at the Gerald Schoenfeld Theatre in New York City on August 23, 2012.

I had just been handed a piece of paper with the running order for the memorial of Gore Vidal printed on it. Gore had died just weeks before and his play *The Best Man* was currently playing on the very stage I—squashed between Cybill Shepherd and a film clip of some of Gore's most pithy moments—would soon be speaking on.

I think Gore would have approved of the piece I read. It was an essay of his (so already he'd think it a great idea!) written for *Esquire* magazine about bisexuality. "We are all bisexual to begin with" was its opening gambit.

And I *know* Gore would approve of me writing about him now.

Once, you see, I made the big mistake of telling him I was having some difficulty in finishing my first novel. Gore wasn't the commiserating type: "Well, of course!" he snapped. "You're not a novelist."

I remember debating if I should tell him that I had read one of his novels and I didn't think he was one either, but I quickly

Dick Cavett

Elaine May

Romulus (Sarandon, Mays)

Cybill Shepherd reads Peter Bogdanovich

Alan Cumming

FILM CLIP 2

Richard Belzer

One-Liners (Elizabeth Ashley, Candice Bergen,

Christine Ebersole, Anjelica Huston)

Elizabeth Ashley

Dick Cavett reads a message from Hillary Clinton

Dennis Kucinich

Michael Moore

Liz Smith inc. Message from David Mamet

The Best Man: James Earl Jones & John

Larroquette

told myself that would be wrong, that I'd only be propagating the stereotype that all writers are bitchy and vicious about other writers (especially younger, inexperienced ones who appear to be blithely writing novels from a supine position in their trailers between takes on movie sets).

And anyway, everyone knows the artists who are the least supportive of their peers' work are directors.

However, I hadn't actually read any of Gore's novels, only a book of essays and his memoir *Palimpsest*, which I'd finished just a couple of hours earlier, rushing through the last chapters on the train that afternoon like a guilty schoolboy cramming for a tutorial.

Gore had told me I should read it, you see, at our last meeting. We had met for breakfast at the Plaza Hotel in New York, supposedly for me to be persuaded by Gore to be in a Broadway revival of his play *Visit to a Small Planet*, but mostly we just laughed and exchanged lurid gossip, our fun interrupted only when the producer of the ultimately aborted production— the aftermath of September 11 making Gore's satire of the US military less than likely to be a Broadway crowd pleaser— turned up and we pretended to be talking solemnly about the piece and the various cuts and updates Gore had in mind for it.

And Gore really needed some fun that Saturday morning, as days later he was scheduled to attend the execution of Timothy McVeigh, the Oklahoma City bomber. I know, you couldn't make this up.

Timothy McVeigh himself had asked Gore to attend. Gore had written (provocatively, natch) about his case a few years before, and they had kept up a correspondence. As we waded through the Plaza Hotel red tape that stood between us and a boiled egg after 11:00 a.m., I remember thinking how awful it must be to be invited to watch someone be killed. How awful,

and of course, how impossible an invitation to refuse. But the execution was postponed at the last minute, and soon after Gore returned to Italy, relieved, I imagine, to be so far away when the reprieve ended and McVeigh was finally given his lethal injection.

So having just finished reading *Palimpsest,* I was now sitting opposite the man himself, hearing Gore recount many of the anecdotes contained in the book, and it was weird. Like having drinks with an audio book. When he started the one about Klosters and Greta Garbo saying how she wished her genitals got smaller as she got older, it was all I could do to stop myself from chiming in with the punch line.

"Write about what you know," Gore continued.

I wanted to say that I was, I really was, that my novel was more or less a thinly veiled account of a rather debauched time in my life combined with a few half-baked theories on how the inexorable, possibly physical yearnings for fatherhood might be combined with the inexorable, definitely physical yearnings for taking lots of drugs, fucking everything that moves, and accepting no responsibilities whatsoever. But I didn't have a chance. He was off.

"You get around the world, you meet interesting people like me, you have ideas. Write them down! And *analyze,*" he said, with great emphasis.

Gore, his partner Howard, my then boyfriend, and I were in the rococo study of Gore and Howard's Italian home. My boyfriend and I had arrived earlier that evening after a perilous moonlit taxi journey along the Amalfi Coast's cliff tops, followed by a precipitous and spooky walk down the path from the village of Ravello, finally emerging from the gardens' shadows to see Gore in a shaft of moonlight, propping himself up against the doorway of the villa, citing our tardiness

for dinner as the reason for his and Howard's already quite advanced stage of inebriation. ("I'm floating," was Howard's opening gambit.)

I really liked Howard. I liked Gore too of course, but Howard had fewer chances to get a word in edgewise and make you realize that you liked him, so I like to think that over their years together he had honed his one-liners down to such a degree that practically every one was a gem. Gore, not in Howard's presence of course, called him "a wisecracker" and smiled fondly—fondness not being one of his biggest traits— and that really describes what Howard was.

"Write about this weekend, write about two men who have been together for over fifty years and yet have hardly ever had sex. Analyze that."

As Gore said this, Howard, he of the over fifty years with hardly any sex, was sitting in a nearby armchair, dwarfed by its size and cushions, the ever-present cigarette dangling elegantly from one hand, the other hand guiding the tongs toward an ice cube from the silver bucket next to him, saying nothing (for now).

Their relationship did indeed fascinate me. They had been together at that point for fifty-two years and seemed completely dependent on, and loyal, to each other.

But Gore has written copiously about his other lovers, his fear of commitment, and that he had never been in love except once, briefly, with a fellow schoolboy named Jimmy Trimble, whose death soon after their teenage love affair ended has haunted him and his work—*Palimpsest* being practically a love letter to Jimmy interspersed with later life episodes. I wondered how Howard felt about all of that.

Howard and Gore had met in the aptly named Everard Baths on 28th Street in New York City in the late 1940s. It was there that they had had some sexual contact ("mostly in

the presence of others" as Gore delicately put it). And it was an envelope from there, one of those you'd leave your valuables in before you set off down the corridors to seek succor in the arms—or at least the hands—of a stranger, that I saw framed in the loo off their villa's kitchen.

Gore feigned outrage when I asked him what this envelope was and why it was there, but soon began to talk fondly of those halcyon days when men of all sexualities gathered and where, he said, you could have *anyone*.

But soon homosexual became a noun as well as an adjective, and the word "gay" came into being and the ghetto walls were put up and the straight men who'd frequented the baths ("It was cheaper than a hotel and they could get blown") got scared and began to stay away because they didn't want to be associated with all that, and the world changed and became the compartmentalized place it is today, where not just your sexuality but details of your preferred role in the sexual act need to be decided upon in advance and offered up early in any conversation or within earshot of a prospective sexual partner.

It was a long night.

Gore was swaying now, and beginning to needle me. He could feel I was taking him up on his challenge, that by questioning him about his views and past adventures I was indeed trying to analyze his and Howard's relationship. So he kept throwing challenges back. At one point he turned to me and said, "Don't you hate commitment?" Remember that my boyfriend was sitting opposite me.

"No," I said, thinking carefully. "I don't hate it."

"But you obviously aren't that fond of it by the way you responded."

"Well . . ." I was beginning to feel uncomfortable. Gore could feel it too and I could tell he was enjoying it. "When I

make a commitment I like it. I don't like to feel trapped, but I think it depends on the type of commitment you make and the rules therein."

In the second that Gore was honing his next salvo I decided to retaliate. The hunted became the hunter: "*You* seem to be the one with the commitment issues, Gore."

There was a pause for a moment. He slurped his whisky. "Oh yes," he said.

Gore suddenly reminded me of Tommy, the eponymous hero of my unfinished book, running around shagging everything he could and refusing to be pinned down or defined. But then, unlike Tommy, he had had all that in his life *and* commitment. Gore had no commitment issues. He had been committed to Howard for more than half a century. What he had a problem with was *admitting* his commitment.

He started to talk about never having loved.

"What about Jimmy Trimble?" I asked.

"Ah yes." I could tell he was torn—half pleased I had done my homework and read his memoir, and half pissed off that I was interrupting his lament. "I didn't realize how much he meant to me," Gore conceded.

"But you weren't really in love with him though, were you?" I asked, knowing the answer already, but needing to make him say it aloud.

"How could I have been?" he snapped. "We were so young. We were just friends fooling around."

"You were just infatuated with him?"

"Yes."

"So you've never loved, Gore?"

"No."

I didn't believe him.

I suppose I should have been more outraged that he'd just

admitted that the central theme of his memoir was a lie, but I wasn't. A human being in his seventies sitting in front of me asking me to believe he had never been in love was far more outrageous, I thought.

Just as he had never properly acknowledged the commitment he had made to Howard, I felt he couldn't admit to being in love.

I couldn't understand it. The usual recipe of shame and self-loathing you might attribute to a man of his generation in such a scenario just didn't wash: he'd been very vocal about his male partners. And his female ones. In fact, let's face it, Gore has been pretty vocal about everything; his third novel, *The Pillar and the City*, is very graphic in its description of a gay relationship and caused a sensation when it was first published. So it's not as if he has a problem with admitting he likes cock. He just has a problem admitting to liking the rest of the person the cock belongs to.

Over the next couple of days, I began to understand that Gore came from a tradition and a generation where this sort of detached, double-standard behavior was not only tolerated but encouraged.

He mentioned that, as a Southerner, he could completely understand how President Clinton could tell the world that he had never had sexual relations with Monica Lewinsky and believe he was telling the truth. To me, this bizarre notion Americans have that no sexual contact has occurred unless someone gets penetrated (and not orally, that doesn't count) is very dangerous. Firstly because it denigrates, demeans, and discounts any kind of sexual contact that comes before or instead of penetration and secondly, because it encourages Americans to enter into a very dangerous communal lie: that getting naked and having an orgasm with someone else doesn't *mean* anything. I think that's weird. It is not a very healthy culture that doesn't even have a name for non-penetrative sex—apart from the loose, bland, and curiously childlike "fooling around."

It's just plain stupid. Getting your penis out and having someone else touch it or put it in his or her mouth is having sexual relations in my book.

Gore did not agree.

"If I was to come over now and jerk you off, you wouldn't think that was sex, would you?" he asked.

I reflected for a second on how surreal it was to be discussing with Gore Vidal the semantic issues involved in him hypothetically wanking me off in front of my boyfriend.

"Not if you only define the word 'sex' as something that involves penetration, no. But I think we would have had sexual contact," I replied.

Gore continued without registering my response. "If I were to blow either of you, which I might add is highly unlikely, we would only be fooling around."

My boyfriend and I both blanched slightly because Gore had now started to fumble with his fly. But when he got up and walked onto the terrace and proceeded to pee over the cliff into the darkness, we were both relieved and then worried for any unsuspecting Italians who might be downstream of the Vidal flow.

"You Brits are more prone to affection in sex," he said over his shoulder.

"You make that sound like a bad thing," I replied.

He carried on peeing; the subject was closed.

But there it was. In that one comment flung back at me as he pissed quite literally in the wind, I realized what Gore was all about. He had separated love and sex because in his mind the two together were somehow dangerous and wrong. And he may have been right—his recipe had ensured a relationship with Howard that had lasted longer than most marriages, and certainly was superhuman in its longevity in gay terms.

So maybe I shouldn't have felt sorry for him. Maybe he had it sussed and I was the one who should be pitied, flailing around in my love and my passion and learning from my mistakes only that I could not stop making them.

There is one last story from those few days in Ravello that has continued to float around my mind looking for a home, and finally it has. Ironically Gore himself enabled me to do what he instructed me to do, and my final analysis—if this were an exam or if someone's essence and ethos were as easy to capture— would be this story, suspended in aspic, or like a Damien Hirst cow, dissected and able to be viewed from all sides.

It takes place in the Everard Baths. Gore had seen a boy he liked the look of and, in that subtle, silent exchange of looks and body movements that is quickly learned in those environs, had let the boy know he wanted to fuck him. Not just fool around, remember. The boy acquiesced. After Gore had finished, the boy turned round and looked up at him and said, "Have you worked out your aggression yet?"

And Gore could think of nothing to say back.

"I was cleverer than him but I couldn't think of anything to say. I was fucking him because I wanted to get off. He had recognized there was no joy in it."

And strangely, as I returned to my seat in the audience and observed the rest of Gore's memorial, I too recognized there was no joy in it.

Gore had left a great legacy, no doubt, a lifetime of provocation and wit, and there was much, much laughter that day, but every laugh was tinged with a sense of meanness. Clever mean mostly, but meanness nonetheless, and definitely no joy.

I left the theater feeling sadder than I'd thought I would. Gore, it seemed, had forbidden himself joy as well as love. But then I don't think it's possible to have one without the other.

SECRETS AND LIES

THESE ARE TWO of my oldest friends, Ashtar and Susie. I was over at Susie's for Sunday lunch and was sitting in the garden looking back at them and suddenly I just got out my camera and caught this moment.

The thing about this picture is that it has the air of suburban angst that Mike Leigh has catalogued so brilliantly in his films (hence the title) but actually, aside from the fact that we were in the suburbs of London, the situation and the people and the mood of that day could not have been more different.

Again I realize how much I love the way a photograph can mislead, even when it captures exactly what was happening.

DIDDY

I WAS ONCE at a fashion show after-party with my friend Cynthia Rowley and we were playing that game where you look around the room and choose someone you'd like to shag.

Sean came over and he started to play it too. When it was my turn I had a fruitless gander around the fashionistas and then my eyes returned to Diddy. "I think I'd like to shag you," I said.

This is a picture of his reaction to that statement. Truthfully, it is a pale imitation of it, as this is not his original look of feigned horror but a reenactment for my camera half a minute later after I had stopped laughing.

I'd still do him.

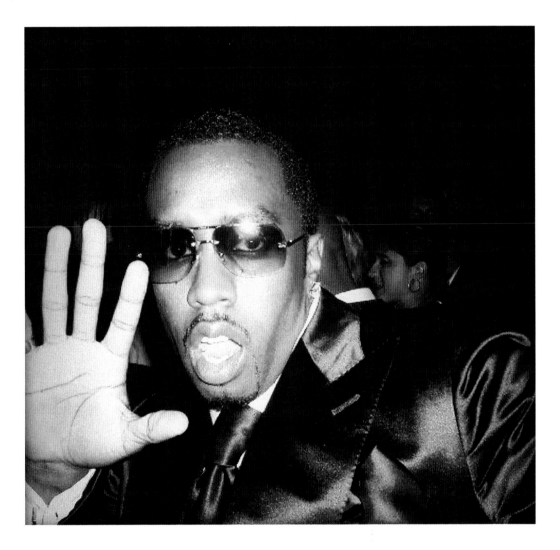

FASHION FEET FORWARD

I LOVE going to fashion shows, though I wish more designers would remember they are actually called fashion *shows*.

Yet even though I long for—and know there are—more interesting and memorable ways to show off clothes than on the requisite bored-looking childlike models stomping down a runway, I do love the sense of occasion, the social hullabaloo, and the drama that precedes a fashion show.

But sometimes it can get a little out of hand. For some, where they are seated—or perhaps even if they are seated—is linked to their ongoing sense of self-worth. The clothes and the show are secondary to the feeling of having a foot on the rung of the fashion food-chain ladder.

And the sad thing is, I don't think it really matters. Well, it matters, of course. To them. You can see that. It is palpable by the utterly rank levels of rudeness and disrespect for other human beings that emanate around those state-of-the-art tents and hastily styled derelict buildings where fashion shows tend to take place.

Fashion, sadly, seems to attract people whose desire to get into it is inexorably linked to the belief that they are more likely to succeed and be popular if they are mean.

And why it doesn't matter: outside of the fashion bubble, no one sensible gives a flying fuck where you were sitting or

which after-parties you were invited to. And actually and thankfully, people who are most successful, on the whole, tend to be quite nice.

And even if they're not really nice deep down inside—I mean if they're actually, truly psychotic and mean to the marrow—they understand that it's easier and more fruitful in life to pretend to be nice, and so they fake it.

Just saying.

NATALIE MERCHANT'S SHOES

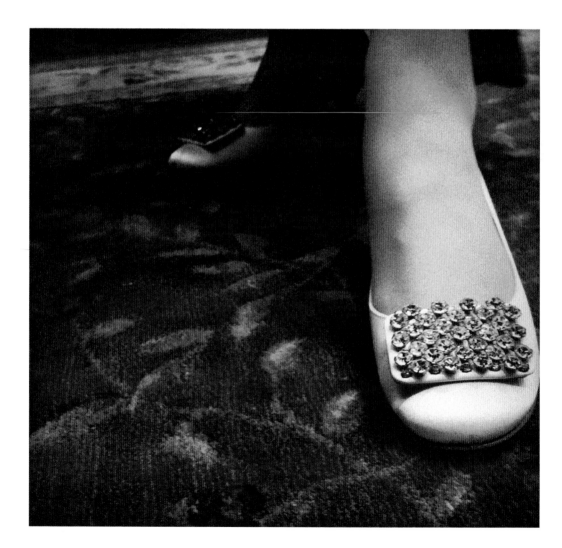

ONCE, AT a charity event, I met Natalie Merchant and she was lovely. And so were her shoes. I asked if I could take a picture of them and she agreed.

Then a few years later, I was directing a film called *Suffering Man's Charity* (though later the title was changed to *Ghost Writer*), and the character I played in it wrote—well, actually stole, so let's just say *published*—a novel and we had to find an image for the cover as the book was going to be an actual prop in the movie.

For some reason this picture of Natalie's shoes sprung into my mind and would not leave. So I asked her if I could use it, and again she said yes.

GETTING TO NOMI

I TOOK THIS picture many years ago in Soho House, London.

Rather bizarrely I was there meeting directors for a proposed biopic of Klaus Nomi, the amazing German countertenor and performance artist who had several hits in the early 1980s before dying of AIDS, and whom I was to going to play in said biopic. It was a rather unusual experience for an actor to be auditioning directors and not the other way around.

Sadly the drafts of the script got less and less fascinating just as I became more and more fascinated with this incredible artist, until I felt I would not be honoring his legacy to remain involved.

This lady worked for the producers and at the end of one of the meetings I asked if I could take a picture of her boots. She obviously thought me a total weirdo for asking but as I was there to inhabit Klaus Nomi, I suppose it only proved their casting was in the right ballpark.

My friend Joey Arias is the executor of the Nomi estate, and more recently there has been another plan afoot to make a movie. I feel confident that with Joey's involvement it will have the right sensibility. As I write this, the project is still

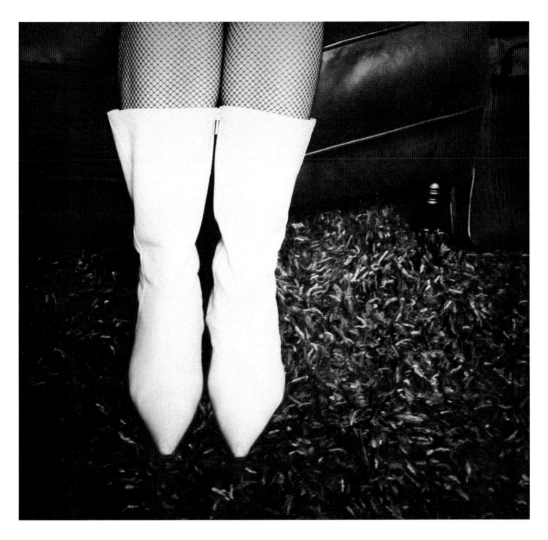

what you might call "nascent," so really the only artistic output I have of my involvement with Klaus Nomi is this picture.

But I am nothing if not an optimist. Many of the projects I am most proud of have taken many years and a very circuitous route to come to fruition, and this one will hopefully fall into that category.

It had better be soon though. Klaus died when he was thirty-nine. I'm a good actor, and luckily alive, but still.

YOU GOTTA GET BIGGER DREAMS!

ONCE, YEARS AGO, at the *Vanity Fair* Oscars dinner in Los Angeles, I met Oprah Winfrey.

I don't know why I even bothered to add "Winfrey" to the end of that sentence. You know who I mean. There is only one Oprah, after all. There are two Madonnas, but only one Oprah. There is only one Cher, of course, but Cher has only ever had one name. She has not risen from mere two-name mortalhood to the pantheon of mono-nameness in the way Oprah has, so I don't think she counts either.

Oprah (omfg!!) and I were introduced by Angela Bassett, who said very kind things about me, and Oprah agreed vociferously. A tad too vociferously I sensed, for I think Oprah didn't have a clue who I was, but nonetheless was very polite and nice to pretend.

A few hours later the after-party was in full swing and I was a bit squiffy. I noticed there were little glasses full of multicol-

ored Sobranie cigarettes on the bar, and naturally I saw this as a sign from the Party Gods that I should start smoking again immediately. It was in the days when you could still smoke within swatting range of a building or another human being so I grabbed a handful and began to make my way back to my booth.

Suddenly my ears were filled with people shouting my name, and then I heard, even more loudly, the name "Oprah" being shouted. Flashbulbs began to pop and I realized that I had turned from the bar and bumped into Oprah and now we had become what is euphemistically described as a photo *opportunity*.

As is required in these scenarios, Oprah and I clung to each other for a few seconds. Then, when we felt the moment had been suitably cemented in media history, we went about our ways. Or rather, she did. Emerging from the post-Oprah glow, I spotted a photographer I knew and said, "You *must* send me that picture!" She did. And I still have it, framed on top of my fridge. Oprah looking patient and professional, me beaming drunkenly and clinging on to her with one hand, the other stuffed with newly purloined fancy ciggies.

MY FRIEND Eddie is a self-confessed Oprah obsessive. His relationship with her verges on that between a supplicant and a god. Really. Now, I think Oprah's great, but from time to time I have been known to utter a small bit of criticism of her or one of the segments of her shows that I've caught. Bad idea. If Eddie were aware, this would invoke a weird coloring to his complexion along with a shrill and menacing tone to his voice, much as I imagine Dr. Mengele would use as he was about to perform one of his experiments. Oprah was Eddie's God, and he could not countenance her name being taken in vain. Sometimes I would actually replace Oprah's name in

those "Yo mamma" jokes just to see this transmogrification in him. It was eerie.

But getting that picture with her and telling him how nice she had been was a turning point in our Oprah relationship together. Now somehow Eddie knew that I got it, that I understood the magic. And actually I did.

A few years later, I was invited to attend an event at which Oprah was going to be honored by the Elie Wiesel Foundation. I knew that I had to go and I knew I had to take Eddie as my date. Grant, my husband, completely understood and so I invited Eddie, and his reaction made me so grateful to the fickle showbiz winds that have blown me hither and yonder, for sometimes they enable me to make another human so very happy.

As the time for the event grew nearer, all Eddie could think about was getting a photo with Oprah. This began to alarm me, as I knew this meant logically that *I* would have to take the photo, and more than that, I would probably have to engineer, through shabby and humiliating means, its taking place. I tried to warn him that although we would be in Oprah's vicinity, it wasn't a slam dunk that a picture would be possible, and also reminded him of those times when we were out together and how annoyed he got on my behalf when people kept coming up and asking for photos of me when we were trying to have a quiet drink or eat dinner. I also tried to go all Oprah on him, saying how surely the sense memory and sheer joy of Oprah just being near him would be within him forever and transcend any mere photographic evidence.

"Yes, you're right, of course," said Eddie to my great relief. "But," he added, "I still would love a photo with her though."

The evening arrived and Eddie and I met at my apartment, both of us bedecked in black tie. I had borrowed Grant's swanky camera to document the evening, but just in case Eddie saw that

as a sign I was weakening, I reiterated: "There is no way I am going to go up and ask Oprah to take a photo with you, okay?"

In addition to the main evening event, we had been invited to a super-duper utterly exclusive cocktail party that would take place just prior. Oprah would be there too, the invitation said. Eddie was apoplectic.

"How many people do you think will be at the cocktail party?" he grilled me.

"I don't know."

"More than fifty? More than a hundred?"

"I'm not psychic, Eddie!"

We were too early, even for the cocktail party. I don't think I have ever been early for a cocktail party in my life but such was Eddie's zeal to soak up as much Oprah fairy dust as humanly possible that we found ourselves standing on the street outside the venue, dressed up to the nines, with nowhere to go, yet.

Perfect, I thought. I had realized in the cab over that I needed to get Eddie drunk.

"Let's go for a martini while we're waiting," I said, starting off down the block to a conveniently located bar.

A large shot of straight liquor took the edge off Eddie's nerves, and also made me pleasantly woozy. Off we exclusively toddled.

CONSIDERING THIS WAS an event being thrown by the Elie Wiesel Foundation, named after the writer, political activist, Nobel laureate, and, get this, concentration camp survivor, it was not a surprise to find that Eddie and I were the youngest people in the room by about fifty years. That, added to the hallowed hush of any throng that was expecting a visitation from Oprah, made the cocktail party a little, well, how can I say this without sounding mean? *Dull*. A lovely Upper East Side lady

was chatting to me but I couldn't focus on anything but the provenance of the animal that was around her neck. Was it a fox? A raccoon? Surely not a favorite pet? I had another gulp of martini and just then heard someone trill, "Alan, darling!"

I turned round to see Iman waving at me from across the way. And there was her lovely hubby, David Bowie, too. I have known Iman from being at events like this for years and always looked forward to having a gossip with her. And here she was with David to get this party started! I beamed back at their smiling faces and began to cross the room to join them. Suddenly their faces changed from happy-to-see-me to abject horror, and so did everyone's around them. There were gasps and a bit of commotion and I realized that in my eagerness to get to them, quite possibly combined with the effects of my second martini on an empty stomach, I had kicked away the walking stick that a tiny, frail man next to me had been leaning on, and he was cascading toward the floor and surely a series of broken limbs. This man had quite possibly survived Auschwitz and now I was to be his Angel of Death.

Luckily, there were some sprightly octogenarians there and the man was caught, righted, his stick was found, and after I'd profusely apologized, the whole thing was forgotten. At least by me. Cancel, continue, I always say.

I introduced Eddie to Iman and David but I could see that Eddie's mind was elsewhere.

"Oprah's in the room," he whispered conspiratorially. "She is actually in this room."

"Where?" I asked. And then I saw a sort of whirlwind over by the door and knew she must be at its center. Very Famous People create whirlwinds, you know. People careen into their vision for a second to pay their respects but each Very Famous Person never actually stops moving and the Respecter is spat

out into the shallows again before they know what has hit them. I could see Eddie looking longingly at the whirlwind. Just then, Gayle, Oprah's best friend, appeared to say hello, and I could tell that Eddie was sated for now with just the Oprah osmosis Gayle imparted.

Very quickly, Eddie, as though via sound waves that only rabid Oprah fans can hear, informed me that she was gone. It had just been a drive-by. I got him another martini to curb his woes and we headed down to the ballroom for the main event.

The layout of the room was as such: there was a big, long table in the middle, where Oprah and her guests like Steven Spielberg and Kofi Annan and Jesus were sitting (only kidding about Jesus), surrounded by lots and lots of little circular tables. It was as though we were satellites orbiting the sun that is Oprah.

When we sat down I could sense Eddie was a little anxious about our billing in terms of the table location. We were, admittedly, on the outer reaches of the Oprah universe, but conveniently located for the loos and the kitchens and the exit. We sat down and tucked into our salads, and, as our fellow table guests began to appear, we happily realized we were not on the Siberia table after all.

The lovely Edie Falco sat down next to us and we immediately started to laugh and have fun. Then Elizabeth Berkley, best known for the iconic *Showgirls*, appeared with her strapping beau. She was a hoot, and I was particularly impressed when she told me about the website she'd created so young girls could ask her questions about sex education and boys, two topics I feel *everyone* needs a little help with.

Before too long the room was hushed, and a ball of glowing peachness walked onstage. It was Barbara Walters. Barbara has the amazing quality of always looking like she is being viewed through a soft-focus lens, *in real life!* Once when I was on her

show *The View*, she came into my dressing room to talk about some questions she wanted to ask me on air, and I actually gasped. It was as though she was floating in a ball of effervescence. I felt as though I was having a religious vision. Eddie already was amped up, and the appearance of Barbara sent him into a new stratosphere of excitement. He was practically vibrating.

The ante was further upped by performances by Itzhak Perlman and Jessye Norman, and then Barbara uttered the immortal words, "We're going to take a little break, and when we return . . . Oprah!" Eddie turned round and beamed at me. Little did he know that in mere seconds his life was about to change forever.

Everyone began to stand up and table-hop. The mood of the room was giddy, high on the flowing wine and the inhalation of the very nearness of Oprah, as well as apprehension about what she would say and what new life lessons she would impart in her imminent speech. Just then Gayle, Oprah's BFF, swept up to our table and asked us if we were enjoying ourselves. We nodded vigorously. Someone tapped Gayle on the shoulder and she turned away. Suddenly I saw my opening. From my point of view, Eddie's head was right next to Gayle's bum, and if I couldn't get a shot of him with Oprah surely a shot of him with Gayle's ass would be a valiant runner-up?! (Please note I had been drinking.)

I told Eddie to turn his head toward me and in an instant I knew he got my plan. But just as I had taken the photo I thought would be the talking point of the night, Eddie, with his hawklike gaze, had spotted that Oprah had stood up at the central table.

"Zoom in on Oprah and I'll be in the foreground," he said, giggling and giddy. I started to fiddle with the camera's buttons in order to do so, but when I looked into the lens again I was

shocked to see that Oprah had not merely stood up, she was walking away from her table. And she was not merely walking away from her table, she was totally walking in our direction!

And then it hit me: Oprah was going to the loo, and her trajectory to do so was going to take her right past our table!!

"Eddie! She's coming! She's coming this way! She's going to pass right by us!" I was trembling, trying to un-zoom the camera that was still aimed at unattainable, Goddess Oprah, just as real, touchable, just-like-you-and-me, needing-to-pee Oprah was mere feet away!

I turned the camera off in my panic, but miraculously got it back on just as She was upon us. I lifted it up and aimed it toward her. The screen was a blur and I realized I *still* hadn't mastered the zoom. As I frantically pressed buttons and fingered knobs I heard Eddie say, in a very endearing and choirboy-like voice: "Oprah! May I have a picture with you? It would be my dream."

My camera fiddling reached fever pitch, and then she said it. She spoke to Eddie. And this is what she said . . .

"You gotta get bigger dreams."

She paused, much in the way she had paused beside me all those years ago in LA. The room stopped. I held up the camera in my shaking hands. The flash went off. By the time I looked at the image she was gone. My heart was thumping. I turned to Eddie, who still had the beaming grin he'd had through the camera lens. For a second I imagined he would never be able to stop smiling. He would go through life with this Winfrey's Palsy, forever trapped in the moment when his idol spoke to him.

"Did Oprah just dis you?" I asked.

"Who cares?" said Eddie. "Let's see the picture."

This was the picture . . .

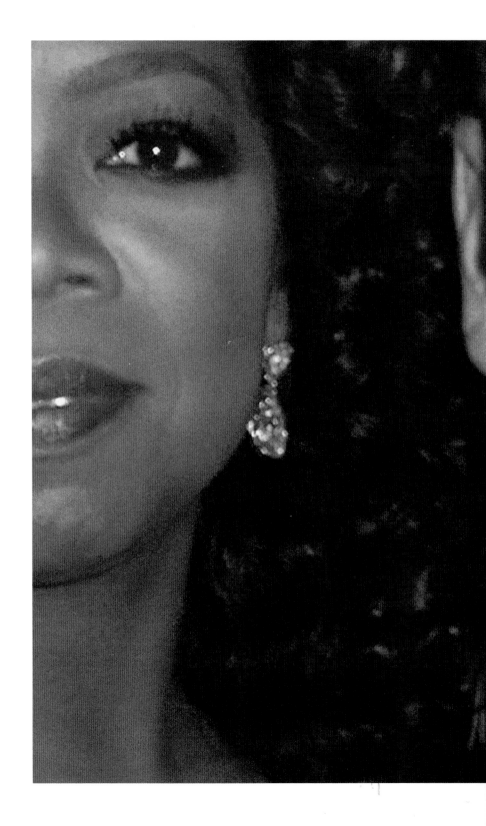

Not one of my best in terms of conventional composition I'll admit, but in retrospect I actually think it really captures the moment perfectly: Oprah is perfectly in focus and radiant, but, of course, like any Goddess, she cannot be fully present. Eddie on the other hand cannot be more present. And his perfect blurriness is exactly how I would wish to both describe and remember him in that moment.

Eddie's friend Scott is a painter and he did an oil painting of the photo, which now hangs in the hallway of Eddie's apartment. Eddie is still blurry and Oprah is only half there. It's beautiful and weird because of its size and I like that it is both a memento and another piece of art born out of our magical moment together.

And I don't think Oprah dissed him. I actually think she was being self-deprecating, and even in that moment of dutiful dealing with the public, something she must do with monotonous regularity on a scale none of us can ever imagine, she was still able to impart something wise and true. Eddie did need to get bigger dreams, and by allowing me to capture that half-present, blurry moment, she released Eddie to contemplate those dreams, for one of his biggest dreams had come true.

KYLIE

ON THE FOLLOWING PAGES is another snap in the series of pictures I have taken of my friend Eddie with very famous women, though this one was not nearly as stressful for me to take as my previous attempt with Oprah, and is also framed better and more in focus.

We had all gone to see the gorgeous Kylie Minogue in concert, and she welcomed a whole throng of us into her dressing room after the show at the Hammerstein Ballroom in New York City.

Kylie is not only a sensational live performer but also the most darling, kind person. She once sent me an email at two o'clock in the morning with a recipe for vegan key-lime pie. She had just come off a tour and the backstage caterer had made it for her and her dancers every night. I'd said it sounded delicious, so when she got back to her hotel room she looked it up and sent it to me before she went to bed. That's the kind of gal she is.

Eddie, I have realized over the years, is like a magpie and has an uncanny radar for sparkly things. He at once zoned in on the exotic headpiece Kylie had been wearing in the show, now stuck on a wig block in the little room packed with well-wishers. Within seconds it was on his head and Kylie was posing with him.

It wasn't till later that I noticed the epic photobomb by Rufus Wainwright, wearing yet another headpiece of Kylie's.

KITTEN

FOR THE FIRST half of 2006, I spent most nights of the week with Cyndi Lauper and we painted the town *red*.

We were performing together in *The Threepenny Opera* at Studio 54, but the show really began when the curtain came down and we headed off into the night with our posse. There was even mention in a magazine that the newest drinking game in town was taking a shot every time you saw Cyndi Lauper and Alan Cumming in a gay bar. Very soon you'd develop a serious drinking problem!

It was just one of those magical few months when you get to know someone, fall in love with them, they become a weird part of your family forever, and you just have LOADS of fun. We'll always have a special bond, and she'll always make me howl with laughter even when she doesn't mean to at all. That winter/spring she kind of became my evil twin.

This was taken backstage, just outside the door you'd enter to walk onto the stage, and they'd put a blue gel around the light bulb in case it shone onstage when the door was opened.

At a certain point in the second act I would be running down the stairs after a quick change and would pass her sitting on the steps, looking gorgeous, bathed in the blue.

This was her first show on Broadway, and she said later that she felt I led her around like a little kitten, showing her the ropes and such, and so whenever I see her I always greet her with, "Hello, Kitten."

IMAN

IMAN IS THE perfect model. I mean that she is always conscious of the camera and knows exactly how to project any emotion. She is like a silent movie star. She is also totally hilarious.

I took this picture at a raucous party for the launch of her book *The Beauty of Color* in Los Angeles. I was in town filming something and she had asked me to be her date. My strongest memory of the evening is that she asked me at one point to look after her purse while she went to do an interview. The look in her eye as she entrusted this task to me left me in no doubt that this was a serious responsibility. She was gone for a while, and I really needed to go to the loo. A close friend of hers said not to worry, she would look after the prized purse in my absence.

Of course, what I am failing to mention is that this close friend was Janice Dickinson. She and I had been having quite a few drinks and taking funny pictures. I seem to go through phases or themes in my snapping, and at that point it was to do a series of three consecutive double selfies of me and whoever else, portraying "happy," "angry," and "sad." Janice

couldn't quite get the hang of it, and each time I looked back on our efforts I felt we needed to do it again as her three emotions did not look very different. I began shouting "Happy! Angry! Sad!" to remind her to change expression. It was only after several fruitless attempts that she grabbed my arm and said, "Alan, my face doesn't move that much."

Anyway, Janice assured me she would guard Iman's bag so off I tottered to the bathroom. It was in the club at the bottom of the Roosevelt Hotel, full of drunk, beautiful, chatty people. I did my old trick of pretending to be on the phone so I could get to the loo quickly. It really works. You just hold your phone to your ear, maybe putting the index finger of your other hand in the other ear to signal you are really concentrating on your call, and you can also stare at the floor or up in the air in the way people really do when they are listening to someone on the phone, and therefore you can avoid eye contact with people. If anyone does actually grab you to try to engage you in conversation, you just put your hand over the phone's speaker and whisper in an apologetic way, "Hi! I'm on the phone," and carry blithely on. I was in the bathroom in no time, but there were loads of people I knew there too, queuing up to get into the cubicles, so I continued to pretend to be on the phone as I peed (not as easy as it sounds, especially when it comes to zipping up) and then back again till I was at our table. Janice was there chatting merrily away to someone and I tapped her arm and said, "I'm back. Where's the bag?"

Her face immediately registered deep, deep shock, even for her, and I realized my folly of entrusting her with this most precious item.

"Holy shit, I don't know!" she rasped.

Can you imagine losing Iman's bag? Her bag that she specifically asked you to take very good care of, and the only

task she had given you in this whole evening of joy and laughter and glamour and free booze that was being Iman's date? *Iman's date!* And can you imagine having to tell Iman that the reason you lost her bag was because you needed to go for a pee and you left it in the care of *Janice Dickinson*?!

Luckily the bag was sitting in a chair just a few feet away from us, so all was well and I had it safely back in my grasp by the time Iman returned. Later I told her about the drama and she laughed her head off. But wow, that was a close call.

Iman once came to visit us for lunch in our house in the Catskills. We had a lovely girl named Grace doing up our garden at the time and Grace came to the door and said she needed us to decide where we were going to put the fire pit. So Grant and Iman and I trooped outside with the dogs, and when she saw where I'd planned to put it she began to tut.

"No, no, no," she said in her deep voice. "You are crazy! You're making a big mistake!"

"What do you mean, Iman?" I asked, fascinated.

"You must put it over there, so you can see the view of the hills," she said, pointing to a spot farther away from the house.

And you know what? She was absolutely right.

Every time I am sitting around that fire pit, munching my beans and veggie burger, looking out as the purple dusk of sunset sweeps across the Catskills, I smile to myself and silently thank Iman. We even named the fire pit after her.

HEAD DOWN, EYES UP

I LOVE THIS picture because Honey is giving me her fiercest supermodel pose. Head down, eyes up, the whole works.

I rescued her from the jaws of death at the pound, and a year later she was the guest of honor at a cocktail party at the Chateau Marmont in Hollywood to celebrate our anniversary.

She never looked back.

I have never known a dog to so enjoy being photographed. She would sit and pose for me, and if I missed a candid moment she would actually reenact it. I don't know where she got it from!

Honey is still is my longest and most successful adult relationship. The one with my husband will supersede it in a couple of years, and what a bittersweet party that will be.

I adopted Honey on a total gut whim, if you understand what that means. I had no desire to get a dog. I was newly living with someone in a building that didn't even allow dogs, yet when my friend Whitney, who was fostering dogs from a rescue organization, told me one night over dinner in early 2001 about this sad, beautiful, exhausted puppy whom she had left sleeping in her apartment, I felt we were meant to be. And I still do.

Honey is dead now. She had a long and happy life and at age fourteen we had to put her to sleep. On the opening night of *Cabaret* on Broadway in April 2014, I was having my makeup put on when my phone rang and I saw it was our vet. I answered.

He told me the little lump Honey had on her groin that I thought was maybe an infected bug bite was actually stage-four cancer, and it was only a matter of months before our darling girl would shuffle off her mortal coil. The vet talked me through the different options for her palliative care, all of which involved potentially hideous changes to her standard of life. He also counseled me that we would know when it was *time*. When I hung up, half an hour before I was to walk onstage and launch the revival of what is perceived as my greatest theatrical success, I was a weeping mass of sadness and loss, and all I wanted was to hold her and tell her, wordlessly, as I'd done daily since she came to me, scared and skittish and with a swathe of yellow paint along her side, that I loved her so much and I would always look after her and she never needed to worry.

We tried the mildest form of chemo for about a week but it made her dazed, lose her whole sense of self and pee all the time. She was absent. When we stopped the pills, she bounced back, still old and creaky and unknowingly pooping all the time, but happy and *present*.

The vet had said we would know when it was time, and we did. One night I was filming a late-night web interview thing after a performance of *Cabaret*, and when I switched my phone on after we wrapped there were a ton of messages from Grant—in one of them I could hear Honey retching in the background. By the time I got home she had gone into a near-comatose state.

Honey didn't regain anything that resembled conscious-
ness. She was now truly absent, and I have no doubt we were
really doing her a favor when we took her to a nearby animal
hospital and she was put to sleep. I can't explain fully how
much I learned from Honey's death in terms of what I now
think about quality of life. I used to associate quality of life
with those lists of the best cities to live in, with the least air
pollution and the cheapest houses and the tastiest restaurants.
Now it means something very different to me.

And although I am a total atheist, I saw on her last night
with us that Honey's spirit had gone, and it was that time the
vet had talked about.

SHONA AND KERRY

WHEN I WAS a little older and able to do with my hard-earned cash as I wished, I got out the plastic camera I won in the raffle and gave it another go. And this time, for fear of retribution about my framing skills, I used my dogs as models.

Shona and Kerry were West Highland terriers and my constant companions on the long traipses I took though the woods each night. Because of my dad, the mood at home was dark and fearful, so the forest was where I found freedom, and freedom of expression. I would make up stories, mostly about being a spy thwarting crimes in the middle of a forest, aided by his two super-intelligent dogs, and barring the tantalizing appearance of a rabbit, Shona and Kerry would play along and were pretty convincing.

One of the pictures I took was a particular favorite of my father's (see following page). Shona and Kerry were sitting on a pile of logs in the evening sunlight. He liked it so much that after Shona and Kerry died he took my only copy of it and had it made into an oil painting by a local artist. For years I missed that photograph, but eventually, as I've found life has a tendency of doing, what I missed came back to me in another form.

My mum had somehow procured the painting when she and my father split up and many years later I realized it was in her attic. It now hangs above my bath in the house I have

in the Catskill Mountains, and it seems appropriate for it to be there, as I now understand my country retreat means so much more to me than just a respite from the hurly-burly of my life in New York City: it helped me come to terms with my childhood. Indeed, when my brother first came to see my place, he stood with me on the deck, looked up at the trees and out at the roaming hills, listened to the sounds of them all for a minute, then said, "You've bought your childhood, Alan."

And I suppose I had, in a way. I had reclaimed, or inadvertently attempted to re-create, all the good parts of growing up: the peace, the solitude, the proximity to nature. But I'd done it on my terms, with none of the negatives. Without my father, basically.

And I still get to say good-night to Shona and Kerry as I climb the stairs to bed.

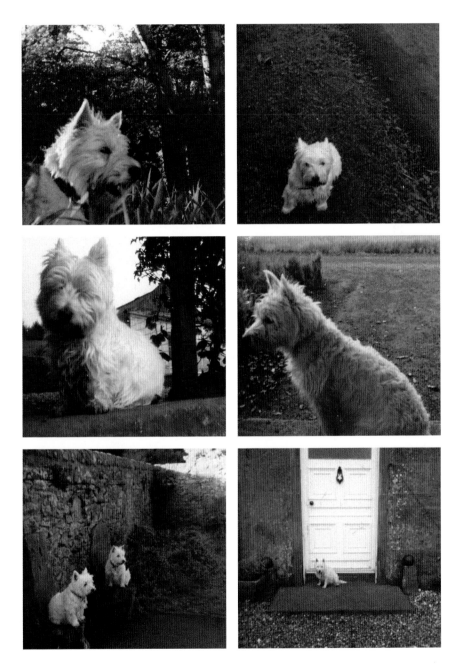

LEON

WHEN GRANT came into my life, so did Leon. He was a medium-haired Chihuahua that Grant had adopted as a puppy.

Initially, Leon did not take too kindly to the idea of sharing his dad with me, and certainly not to the idea of sharing a bed with us along with his new, bigger sister, Honey. The first time all four of us slept together was in a hotel room in midtown Manhattan. There was some snarling.

Leon was an alpha male, one of those dogs (or people) whose braggadocio is so out of whack with his or her actual power, or, in Leon's case, his size. In the park, he would lunge at pit bulls, sometimes trying to leap from our arms to do so.

We gave him an imaginary voice that sounded like Elmer Fudd, if Elmer had grown up in Brooklyn. But he had his softer sides too. He was famous in the East Village for bursting into howling song every time he heard a siren, and on the streets of New York City, that happens a lot! He grew to accept and love me and Honey. When she died, he too was bereft; for the first time in ten years, he was alone in our apartment when Grant and I went out.

But Leon's blue-collar-guy persona was all a sham. Once, I came home from work and Grant told me that in a bout of spring-cleaning in his studio he'd found Leon's birth certificate. Although technically Leon had been rescued by Grant, the version I had in my head was a little grittier than the actual truth.

First of all, he came from a famous pedigree breeder—not, as I'd imagined, the result of some late-night liaison on the mean streets of Gotham. Second, his mum was called Diamonds and

his dad Shilo Care Bear! Worst of all, his first home was an apartment in Trump Tower!

But his struggle was real. He was a gift to his first owner, she of the Trump Tower apartment, but she didn't want him and gave him to her decorator, who used to play the piano in his antique shop downtown and Leon would howl along as a little pup. That's where Grant first saw him and fell in love. Soon after, the world was righted and Leon and Grant were together.

So just as his provenance was a little more frilly than I had imagined, his tough-guy act was really just that. He was a softie and a lover—just a little complex. Leon is short for Napoleon, after all.

Here he is in his national costume.

LIFE IS A GAME

ONCE I MADE the mistake of leaving a pile of games under the piano at my house in the country. I'm a big fan of games. I think they are a healthy means of expunging aggression and corralling our competitive urges into an arena where they are called for, instead of—as I'm afraid I have observed happening with rampant regularity in my adopted homeland of America—making *everything* a competition.

How fast can you get there? How long can you breathe underwater? How many drinks can you have? What weights do you lift? How many likes did you get? How thin can you be? How tanned? How pale? How rich? How young? How different to who you actually want to be?!

I think everyone in America would be a lot happier, and certainly a lot healthier, if once a week they gathered together and had a game of Taboo or something equally fun and silly. Those are the occasions when you're *supposed* to be a seething mass of tribal rivalry. It shouldn't be a national pastime.

Anyway, in the midst of a boisterous singsong, I kicked the pile of games over and they fell down the stairs. This was the scene that greeted me when I peered down, and I thought the universe was sending me a message.

Sometimes in life I fall to pieces. But when I'm at the very bottom, I know in my heart I'll be able to scrabble things together and start my journey upward again.

To paraphrase Auntie Mame, life is a game and most poor suckers don't know how to play it.

SELF-PORTRAIT, MARRAKECH

WHENEVER I LOOK at this picture I think of nearly dying.

I took it in my hotel room on a vacation I went on with my husband, Grant, in Marrakech, Morocco, in 2011.

On the day we arrived we had dinner in the Café Argana in the old town square. It's a very famous, old-school sort of spot where visiting Westerners convene and sip cocktails and look out over the balcony at the spice stalls and snake charmers below.

The evening we dined there I remember a Scandinavian family sitting nearby, the mum and dad trying to placate their jet-lagged brood with ice cream. The waiters were so lovely and patient, explaining the idiosyncrasies of the menu to us in broken English. The food was pretty unremarkable to be honest, but we were just glad of some sustenance after a long day of traveling, and we stumbled back to our hotel full and happy.

The next morning we woke up late, groggy and hungry, and because of our jet-lagged haze and having missed breakfast in the hotel, decided to make things easy and just go back to the Argana again for lunch.

But as we reached the square we realized something was wrong. The night before it had been busy and bustling, but now, although full of thousands of people, the whole place had ground to a halt. Everyone was staring at the wreckage of the Café Argana. It had been bombed just a short time before we woke up—perhaps the blast was what jolted us from our slumbers. The only movement was the frantic toing and froing of ambulances and police cars, their blinding, flashing lights unable to break the horrified gaze of the shocked multitudes. Grant and I joined them and were immediately similarly paralyzed.

There was the terrace we had dined on the night before, blood spattered across the wall the Scandinavian kids had been sitting against, sheets covering broken bodies that could easily have been ours. The wreckage was intense. It was like a doll's house had been stamped on.

We wandered round the city aimlessly, sporadically gleaning more information about the bombing from café television sets that would be blaring the minutiae of the tragedy for many days to come. There was no doubt the attack was against people like us. The Argana was the very hub of Western-ness and an attack on it was so pointed that, as we tried to block out what had happened and take in the wonders of a city whose sensibility had so dramatically changed for us, we none-theless felt incredibly vulnerable and exposed.

When we got back to the hotel, the Internet and TV were awash with the bombing and suddenly I realized I should let people know we were okay. I emailed my family and then spoke to my assistant. The reason we were on this vacation at all was because I had hosted an event for the Moroccan National Tourist Office with Angelica Huston back in New York City, and this trip was the prize in return for that task. So it came as no surprise, although it still was a little depress-

ing, to hear that the first two people to contact my office to see if we were all right (i.e., not murdered while on a trip paid for by the Moroccan National Tourist Office) were, ahem, the Moroccan National Tourist Office and then my publicist. Showbiz, people. You gotta love it.

Perhaps to take my mind off what had just happened, and how narrowly we had dodged death, I decided to take some pictures. I started playing with reflections in the stained-glass panels of the balcony door. My eyes give it away though.

I like the fact that this picture is quite colorful and jolly and kind of exotic but it exists because of something really awful.

I like making lemonade.

CAITLIN'S KITCHEN

ABOUT A MONTH before this picture was taken, a very close friend committed suicide. It was shocking, but, as is often the case with shocking things, not altogether surprising. Sometimes the shock is that you almost forgot it might be possible.

It was ugly and messy and unresolved for a time, and the friends left behind had a visceral need to be together, like a wounded pack or a tribe re-communing to make sense of this waste of life.

So we would all gather at Caitlin's flat in Brooklyn. It was at the height of a New York summer, and we spent a lot of boozy nights in her garden-floor apartment, talking and remembering and mourning and healing.

I took this picture very quickly when I was getting a drink and then didn't look at it for a long time. But when I did it took me right back to those evenings.

Although not much tea was imbibed, there was a lot of sympathy, and plenty was smoked. I didn't remember the fly in the champagne glass when I took it, and at first it gave me the chills, but now I think it's perfect. Like everything in life, death completes the picture.

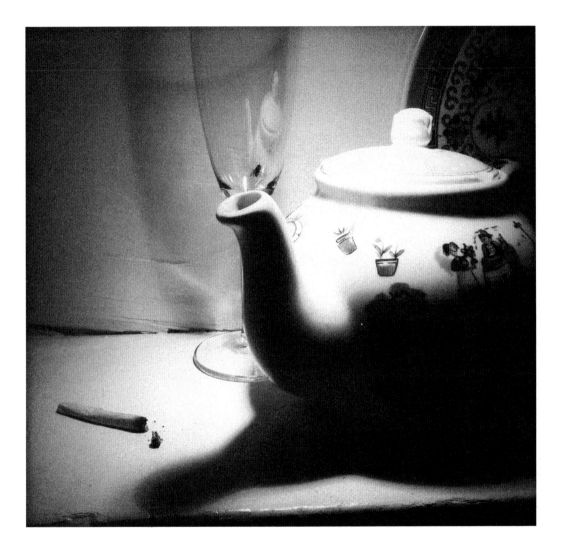

MANDATORY SELFIES

I DON'T WANT to be *that* guy, but I have been taking self-ies since the 1980s, people. Not that that's really a big deal because, let's face it, they are not a great achievement in the grand scheme of things, and all I was doing was turning a camera and eventually a phone around so the lens faced me and whoever else was in the picture rather than pointing it out to the world, and that does not require a degree in brain surgery, BUT . . .

I'm just saying. I was having to accurately self-frame long before the selfie button was around. Okay, kids?

1999, South of France. Showing off my new swimming trunks.

On second attempt.

I had mirrors attached to my garden fence in London in 1994. Suddenly the garden seemed enormous!

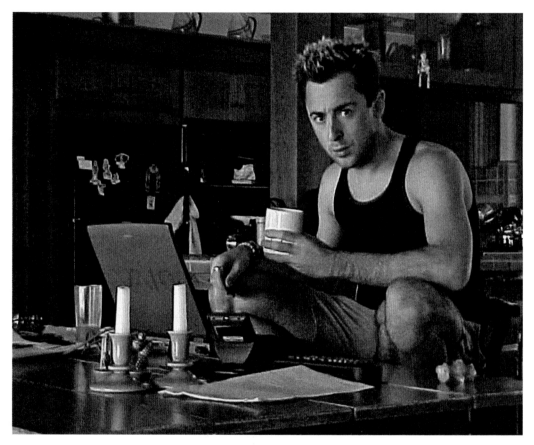

Before there were selfie sticks, there were self-timers.
This moment of nonchalant, moody repose was captured after many
attempts, rushing back and forth between my camera and the table
in my friend Caroline's guest house in 1999 in Ojai, where I had
gone to work on my novel, *Tommy's Tale*. Then, as now, I was a
prevaricating scribe, and achieving the perfect selfie (or "selftimie,"
I suppose we should really call it) could take up a sizable part of
my writing hours. Here I even have the audacity to look pissed off
at being interrupted in my literary efforts! #acting

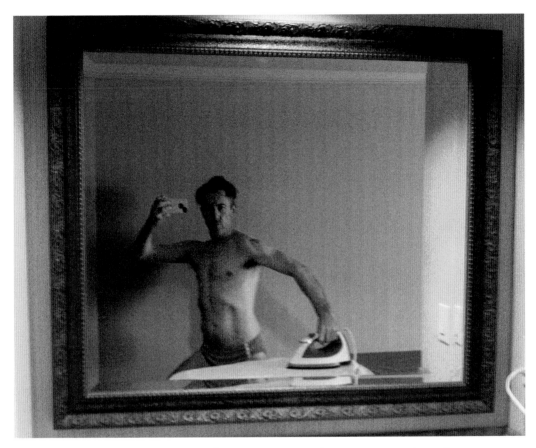

Connecticut, 2012. I am ironing a shirt in my swimming trunks for an event at which I will present and receive an award for Kristin Chenoweth, who couldn't come as she had a neck injury from filming *The Good Wife*!

Following pages: Doing a self-timer tumble in Rome, bored, on a day off from the movie *Titus*, 1998. (And I know, self-timers are not, strictly speaking, selfies, but screw you!)

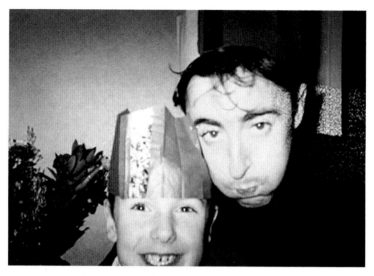

1994, Scotland, with my nephew Gary.

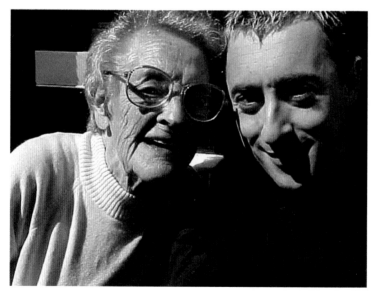

Me and my granny, Inverness, 1999.

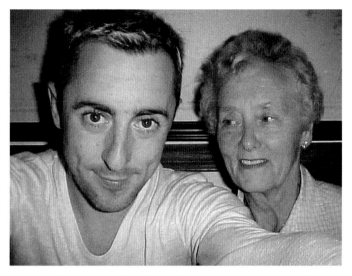

My adoring and adorable mum, Mary Darling,
Inverness, 1999 . . .

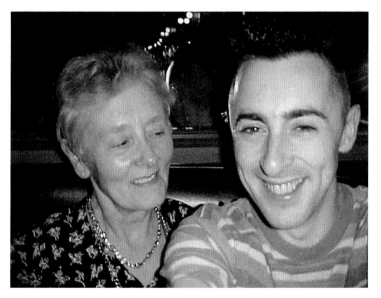

. . . and New York City, 1999.

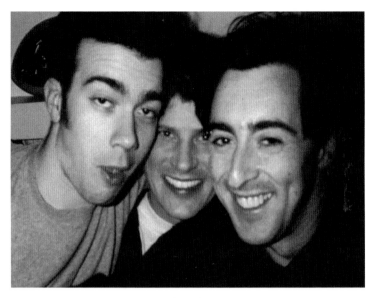

New York City, 1998.

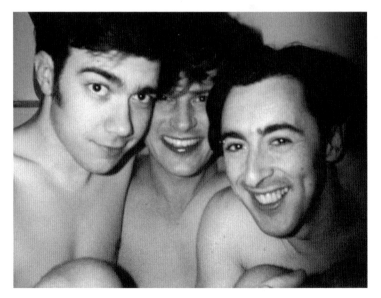

Spot the difference!

Savoy Hotel, 2003.

Two of my most attractive looks. LA, 1999.

Australia, 2004.

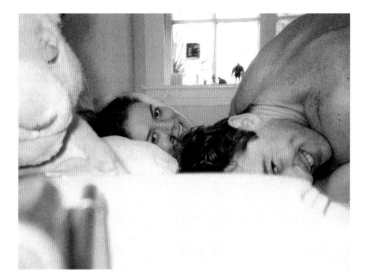

LA, with Saffron, 1995.

2000, Austin, Texas, with Robert Rodriguez on
the set of *Spy Kids* with my prop action figure.

Just two of my chameleon-like transformations. As the Great Gazoo in *The Flintstones in Viva Rock Vegas* . . .

. . . and as one of Loki's disguises in *Son of the Mask*, 2005.

Backstage with Lypsinka at Roseland
for the 1999 *Broadway Bares*.

Fort Lauderdale, 2015. I did a concert with my musical cohorts Lance Horne
and Eleanor Norton, and this legend, Dina Martina, opened for us.

New York City, with Bianca del Rio, 2014.

They were going for a light smoky-eye look.
Kenneth Cole fashion show, New York City, 2014.

The secret of my boyish good looks, 2014.

Channeling Matthew Bourne's *Swan Lake* at a photo shoot for *Vintage* magazine, New York City, 2015.

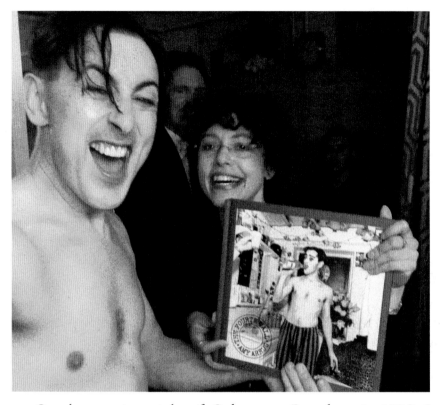

On the opening night of *Cabaret* on Broadway in 1998, I was asked if I would allow a photographer from *The New Yorker* to be in my dressing room as I came offstage, to capture what everyone told me was going to be a momentous night in my life. I said no. I was so stressed out about the show opening and everyone telling me my life was going to change and the last thing I wanted was to have to deal with some stranger and all their equipment in my miniscule dressing room when all I wanted to do was to shut the door and pretend none of it was happening. They asked again. I said no, again. Finally they implored me, implying it was my duty to allow this great moment in theater history to be suitably immortalized. I said yes.

The photographer turned out to be Amy Arbus, one of the nicest people in the world. She understood how I felt and was as inconspicuous as one can be in a room the size of a shoe box with many, many adults squashed into it. The photo she took was indeed a great condensation of an experience I didn't even comprehend at the time, but in retrospect, as I look at that photo from time to time, I can completely reconnect to that moment. She put it on the cover of her book *The Fourth Wall*, and sixteen years later, in 2014, she returned to my dressing room as an old friend, and captured the moment of my opening *Cabaret* on Broadway again.

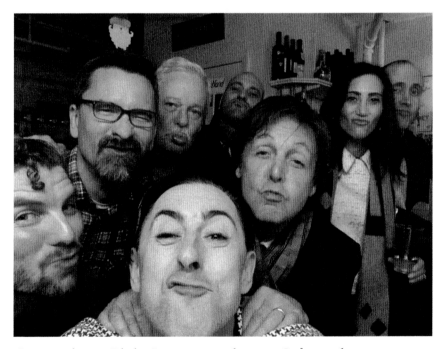

One night at Club Cumming, aka my *Cabaret* dressing room at Studio 54, 2015. Varying degrees of snarl success.

New York City, 1998. Life really was a cabaret.

Seconds after I ended a relationship, New York City, 1999.

Spice World, London, 1997.

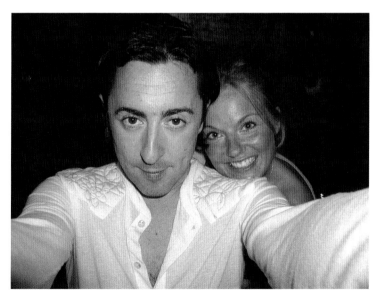

Post–Spice, LA, 2002.

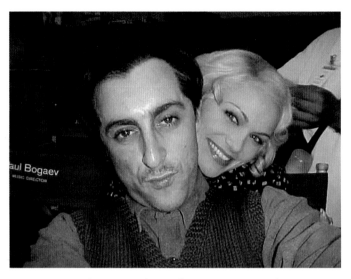

Kristin Chenoweth and me in 1999 shooting
the TV movie of *Annie*.

Sixteen years later, shooting promos for the 2015 Tonys,
which we hosted together.

With Rosario Dawson in the makeup trailer
of *Josie and the Pussycats*, Vancouver, 2000.

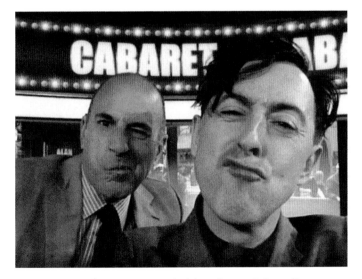

New York City, 2014. Teaching Matt Lauer
the closed-lip snarl, not too successfully.

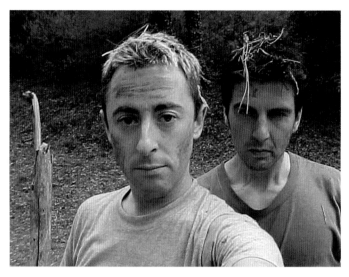

My friend Andrew and I giving Vietnam chic,
Saint-Tropez, 1999.

Puerto Rico, 1999. I am the whitest actor
ever to play Cuban dictator General Batista.

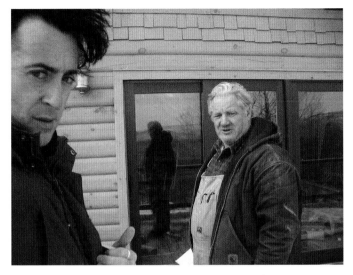

Upstate New York, 2004, with Bob the builder,
the man who built my home.

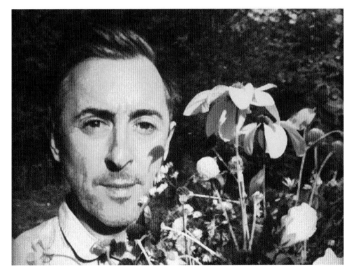

Self-portrait with flowers, upstate
New York, 2011.

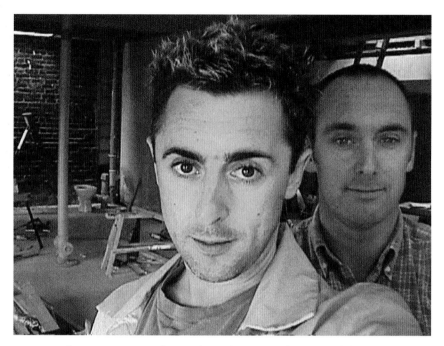

London, 1999, with my brother in what would become
my dream party pad.

This flat was in Chinatown in London and looked down
onto the cinemas of Leicester Square. Once, as I washed the
dishes in the kitchen, I could see my face on the marquee of a
theater showing a movie I was in.

There were two terraces and in order to get trees onto them
we had to shut the street down to allow a crane to drop off
each tree one by one. It was like a UN mercy lift operation.
The top terrace had a Jacuzzi and a little bar and speakers in
the bushes and so was the scene of much merriment. Once I
rented the place out for a year and when I got it back it was
trashed. The people who came to redo the floors said they were
in worse condition than the dance floors they'd seen in clubs. I

couldn't find the console thing that worked the TV projector anywhere until I felt it under my foot in the Jacuzzi, and the cover of said Jacuzzi was also nowhere to be seen, discovered a week later in an alleyway behind a Chinese restaurant far below, obviously chucked there by some high reveler. For years I would meet people, all over the world, who would sidle up to me in some bar and say, "Eh, I think I went to a party once in your apartment in London . . ." Apparently it got so bad that a drug dealer actually set up a stall in the building's stairwell to ply his trade. Much as I was appalled at the mess left behind by my bacchanalian tenant, I was secretly happy that the place was being utilized in the spirit it was created.

Years before, the building had been a hospital for tropical diseases. Once I was doing a movie where I played the god of mischief Loki and the lovely Bob Hoskins played my dad, Odin. At dinner one evening we got chatting and he told a story about how he had once eaten brains at a tribal ceremony in Africa and upon his return to the UK he discovered he had a tapeworm. After many attempts to get rid of it he went to—guess where—the hospital of tropical diseases and had it removed. I asked how such a thing occurred and Bob told me in very graphic detail. It is kind of as you'd imagine, and involves the tapeworm being coaxed out (of Bob's bum) and then pulled and pulled and, well, you get it, pulled. Back in my London flat, I could never rid myself of the image that Bob may have had a huge parasite wrenched from his backside somewhere near where I was sitting on my sofa.

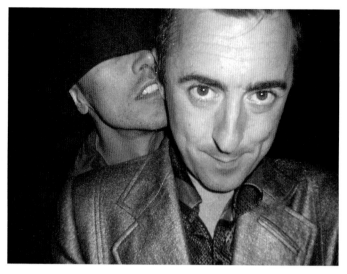

Blooming love, Glimmerglass, 2004.

Family portrait the morning after Grant and I got married in New York City, 2012, on the fifth anniversary of our wedding in London.

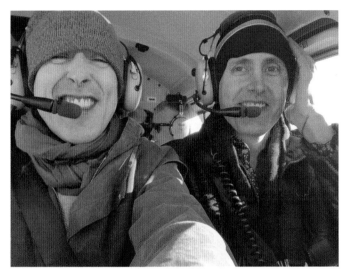

New Zealand, 2015. We went on a helicopter ride
and landed on a glacier!

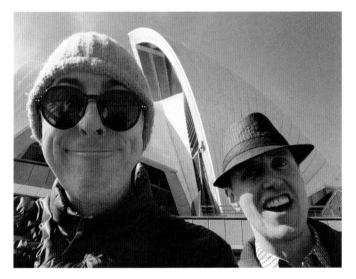

Sydney, Australia, 2015. Doing impersonations
of each other in photographs.

LA, 2000. Happy.

Rescue puppy love, New York City, 2011.

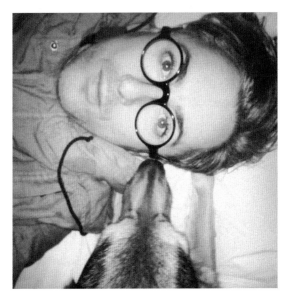

Honey and me, 2011.

New York City, 2013, with Phyllis the raven, my co-star in *Macbeth*.

New York City, 2013. TV boss.

Eli unleashed, just wrapped after a day of filming
on *The Good Wife*, Brooklyn, New York, 2012.

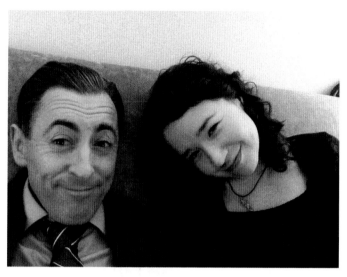

Greenpoint, Brooklyn, 2014, with my
TV daughter Sarah Steele.

New York City, 2014. Last day of filming
season six of *The Good Wife*.

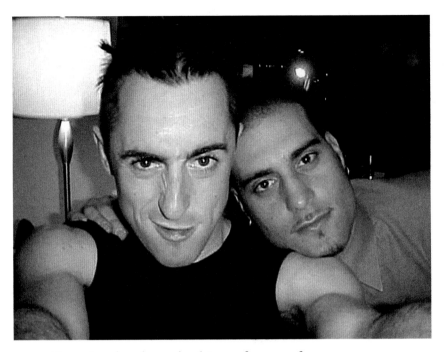

Carmine has been looking after me for many years
and through many hairstyles.

Every time I do a show on Broadway, Carmine is part of my
deal. It's non-negotiable. We have worked together for sixteen
years, and our friendship and love for each other is as strong
and lasting as it is initially confusing to people from the out-
side. And I get it. He is a straight Italian guy from the Bronx
who loves football and poker, and I'm me.

Carmine and I came into each other's lives at a time that
was full of change for both of us. It was 1999. I had come back
to New York to continue the run of *Cabaret* after making
a film in Rome. Before I'd gone things were getting a little
intense. The show had become a sensation and I was unpre-
pared for the furore my performance was causing. Leaving

the stage door after the show was getting more and more overwhelming and even scary. People sometimes followed me home. Going off to Rome and being anonymous for a few months was a very welcome respite.

Just before I left Rome, I called my apartment back in New York to check my messages and heard someone telling me they knew where I lived and then listed in great detail what they were planning to do to me. They were also obviously masturbating as they did so. There were several messages like it. The backlog of mail waiting for me at the theatre contained several notes in a similar vein.

My return to *Cabaret* was heralded with an ad in the *New York Times* with a semi-clad me, looking over my shoulder at the camera with the words "He's Back" emblazoned across it. The experience was all the more overwhelming having been a virtual recluse in Italy, and one day soon after the producers told me they felt it was time for me to have security protection. I burst into tears. Sometimes in life you feel scared and out of control but are in denial, and it's only when other people acknowledge the situation that you really have to face up to it. "I don't want to have someone who looks like a bodyguard," I sobbed, embarrassed to be even having a conversation like this, but slowly realizing that the producers were not just being kind, they were protecting their investment. Suddenly I remembered one of the doormen at the theatre who I'd chatted with and who had helped me to a cab a few times when the crowds were getting unruly. "Can I have Carmine?" I asked.

Suddenly Carmine and I were constant companions. He was the first person I'd see when I left home and got into his car, and he'd be within arm's length all day until he dropped me off there again at night. Everywhere I went, to press events, to the doctor, out to clubs after the show, Carmine

was with me. In the first few weeks he'd even check the closets and under the bed in my apartment. We were both fish out of water, thrown together into a new and unknown phase of our lives. All we had was each other and we came to love each other like brothers. He made me feel safe. He still does. I joked that I was Whitney and he was Kevin, but I knew he really would take that bullet for me.

Since then, we've had years of laughs and japes and scrapes, and I look forward to so many more. Each time I am offered a new show on Broadway, part of the allure is that Carmine will be back in my life every day.

Club Cumming, aka my dressing room
at Studio 54, 2014.

Left, Backstage at *Broadway Bares*, New York City, 1999. Right,
The Tonys after-party at the Carlyle Hotel, New York City, 2013.

Left, Club Cumming, 2015. Right, Celebrating not having died
during my Tonys hosting duties, The Plaza Hotel, 2015.

New York City, 2012, at Hal Prince's holiday party.
I wish I had had pearls.

New York City, 2015, with my goddaughter Gigi and her
mom, Cynthia Rowley, at the latter's fashion show.

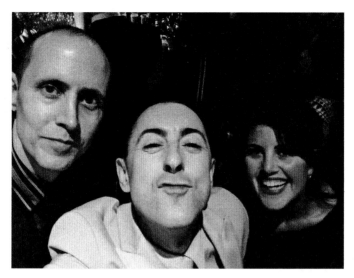

Golden Globes, LA, 2014, with Grant
and Monica.

New York City, *Saturday Night Live* 40th
celebration elevator selfie, 2015.

New York City, 2013. I was a stamp once!

Sesame Street, 2014. Dreams do come true!

One of the times I didn't win the Emmy but just grabbed
one at a party and took this picture anyway, 2015.

Vermont, 2015. Lost.

YES!

THIS PICTURE was taken seconds after I had come offstage from making a speech at the launch of the "Yes" campaign for Scottish independence in 2012. There were a hundred paparazzi sitting in front of me screaming and blinding with me with their flashes. The reason for their fervor was that I had sat down right next to Alex Salmond, at the time the leader of the Scottish National Party and the architect of the entire process that led to the referendum Scots would eventually vote in, eighteen months later.

As I tend to do when I am trying to have a personable, and even intimate, moment with someone but at the same time am overwhelmed with self-consciousness at the sheer mass of people observing and recording said moment, I tried to take something back for myself and so took a selfie. #selfiepioneer

The morning had started very nicely. I was in Scotland rehearsing *Macbeth* for the National Theatre, and a few hours later was to embark on a long weekend's train trip on the Flying Scotsman, around the Western Highlands of my country—in utter luxury I might add—with my husband, Grant, who had just flown in from the States the night before. But before we did that,

I had to speak at the launch of the biggest and most important political campaign there had ever been in my country. You know how you do.

The thing is, I forgot to tell that part to Grant!

I had been vocal in my support for Alex and the SNP before. I supported him publicly in the previous Scottish parliament elections and Grant and I had become friendly with him and his wife, Moira, over the years.

Prior to Grant's arrival in Scotland, I had been updating him on the discussions between the first minister's office (Alex's) and my office to see if we could all either have coffee together on the morning Grant and I set off from Edinburgh, or perhaps a drink the night before, if we were going to arrive early and spend the evening in a hotel.

However, time marched on, and as I got more and more lost in *Macbeth* and there were lots of toing and froing and plans changing, it just didn't happen that I went over with Grant the exact details of the morning we were going to have.

So here's what did happen: We got up after a lovely night in a hotel and hopped in a car and went to have breakfast with Alex at Centotre on Queen Street. We were joined by a few others, including fellow actor and East Coaster Brian Cox and a couple of the "Yes" campaign staff members. I remember thinking how jovial and relaxed Alex seemed even though he was about to go and face the world media's glare as the man who wanted to wrench the United Kingdom apart. It was a monumental day for everyone, no matter what your opinion, but for Alex, it was a life's political work in the making. And we got to have breakfast with him! And it was a great breakfast, jokey and chatty and kind. But as I watched Brian confer with a "Yes" person about his speech, I suddenly began to feel nervous about mine.

It wasn't very long, my speech. I had taken the brief to say a

few words quite literally. But still. It was the launch of the "Yes" campaign for independence of my country, people!

I was also braced for the onslaught from those who felt I should not speak out about my views on Scotland's future because I was not a resident of the country at that time. I felt, and still do, that no matter where I live, I will always be Scottish. I am a product of Scotland, but most of all, I am a human being entitled to an opinion! Disagree or ignore it if you want to, but don't deny me the right to *have* it! That, more than anything I can think of, is not a Scottish thing to do.

I was planning to say how, fifteen years before, I had come to Edinburgh to campaign for Scottish devolution with Donald Dewar, at the time the secretary of state for Scotland in Tony Blair's Labour government. Then there had been two questions on the ballot, and I still had a T-shirt with the slogan of the pro-devolution campaign: YES! YES!

Fifteen years later, here I was back in Edinburgh, with the product of that successful campaign, the new Scottish parliament, just a hop, skip, and a jump down the Royal Mile, and I was campaigning again, but this time, for only one YES!

"I believe independence can only add to our potential . . ." I rehearsed in my head ". . . and release a whole new wave of creativity, ambition, confidence, and pride. The evidence is clear. In the past fifteen years we've become stronger economically, socially, culturally, and globally. The world is waiting for us, and I know Scotland is ready."

It was short, but (I hoped) rousing. I was going over and over it in the car from the breakfast to the launch venue, when Grant said to me, "So, are we going to the train station now?"

That's when I realized I hadn't told him and he had no idea that he was about to be dragged into the center of a huge political event.

He took the news quite well. He had thought the breakfast briefing meeting we'd just had was the equivalent of the coffee we'd been trying to coordinate. And it kind of was, I suppose.

But his face when I walked back to sit down between Alex and him—as literally a hundred human beings with cameras of every shape and hue descended on us, ignoring the next speaker onstage, screaming and also actually blocking our escape should we have needed to get away from the situation—was a picture of massive discomfort mixed with amazement and a great big dollop of jet lag. I can still do a really good impersonation of it.

We were both so delighted to arrive at Waverley station less than an hour later and enter the swanky Flying Scotsman lounge. After the onslaught we'd both just weathered, we were happy to be sequestered and escape the hysteria that the "Yes" launch had engendered.

Good luck with that.

I was on the lounge TV making my speech, very loudly, as we walked in. Everyone was watching it, and everyone saw me arrive.

The next morning we woke up on the train after a beautiful evening traveling through Rannoch Moor and spending the night in Spean Bridge. After a delicious breakfast (and don't you just love to be sitting eating whilst *moving*?) we wandered through to the lounge car. Every single one of the far-too-many Scottish and UK daily newspapers was spread out around the carriage for our delectation and enjoyment, and I was featured heavily on the front page of many of them.

In a funny way, though, being involved with such a big news story and then immediately thrust into the company of a bunch of strangers from all over the world was a wonderful thing. People talked to me about it a lot, and in answering their queries I found my belief in and commitment to independence unwavering and pure.

Nearly eighteen months later, this selfie I took for more joyous reasons. I had flown to Glasgow on my day off from Broadway to do a last-minute bit of campaigning with Nicola Sturgeon, who was then the deputy first minister. The crowds were huge and ecstatic, the first poll with the "Yes" campaign in the lead had come out the day before, the little boy Nicola had picked up between us was wearing a Superman costume, and that is how we all felt. We felt it was possible, that we were going to do it, that our self-determination was inevitable. That the power of YES would win. That's why I took this picture.

PRIESTS TEXTING

LIFE ON TV is just better. I mean, everyone is better looking, their clothes have all just been rubbed over with a lint roller, their hair is nice, their complexions clear, they never have to bother with pleasantries like good-bye at the end of a phone conversation, they never have to go to the coat check. On TV, life just looks better. Believe me, I've seen it from both sides.

Once, Valerie Jarrett, President Obama's special adviser, came to do an episode of *The Good Wife* and I had some scenes with her. In real life she had FBI protection, and so in the show she had actors playing her secret service attachment. The thing is though, these secret service men were TV secret service men, meaning they were bigger, better-looking, better-groomed, better-*nourished* versions of her real-life secret service men.

That's how we roll in showbiz. I play a ruthless, middle-aged, Jewish Chicago politico in the show, yet before every take my hair is coiffed, my tie straightened, and chapstick is applied to my lips and eye lashes. (I came up with the latter but now it has become a part of the Eli ritual.)

Valerie's real secret service men were waiting just out of shot from her hunky fake ones, and I wondered what it must be like

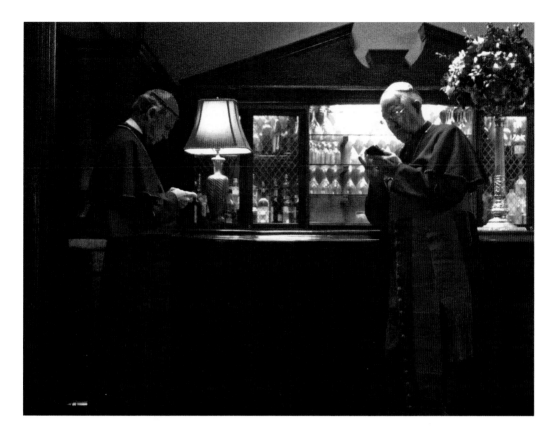

for them. We all joke about the people who might play us on TV or in a movie, but they were having to deal with it a little too close for comfort, I thought.

Anyway, about this picture. Once there was a scene at some big political gala and we spent a couple of days filming it at some big house up in Sleepy Hollow. In a break between scenes I had a wander and caught these two background artistes (that's what we call extras now, btw) going about their normal business, but because they were dressed as priests it just took on such a lot more portent and baggage, and, frankly, weirdness.

Who do you think they're texting, or which app do you think they might be using? See, it gets weird very quickly, doesn't it?

SWEET LIZA

THE FIRST THING Liza Minnelli ever said to me was, "Alan, I want to be your friend forever!" She had just come backstage to see me after a preview of *Cabaret* on Broadway in 1998, and I was utterly overwhelmed by her. Meeting Liza is like watching a hot spring bubbling out of the earth. Her huge eyes open impossibly wide to take in all the wonder she sees in the world around her. She is everything you might expect—a star, a whirlwind, a legend, a flirt, a great storyteller—but the thing above all else I always think about her is this: there isn't a bad bone in her body. She has no malice, even for those who have wronged her. Of course, this is also what makes you worry for her. Sometimes I look at her and marvel at how she has managed to survive in the big, bad old world of showbiz, but she has, and she does.

I remember when she was sixty, she told me she really never believed she would live that long, and I suppose when you have thought that about yourself, the rest of life is just a bonus extra. And that is kind of how it feels being with Liza. I saw her in LA one morning recently, and she thought we were

going to leave her house and go to breakfast, and when I told her that no, I had just popped 'round for a cup of tea and to say hello, her face lit up and she exclaimed in that hiccupy way of speaking when she is happy, "You mean, we don't have to go anywhere? That's terrific."

Another time, when we were performing some concerts on Fire Island, we were in a sort of compound of two houses separated by a shared patio. She mostly stayed inside her house with the AC blasting, watching TV and smoking. But each morning our dogs would be scraping at the door to get out of our place and go and visit Liza next door. Even they knew where the fun was. I suppose I'm saying I think Liza could be happy anywhere.

Years ago we recorded "Baby, It's Cold Outside" for a charity CD called *Broadway Cares: Home for the Holidays*, though we called it *Homo for the Holidays* as we thought it must be the gayest record ever made. On the morning we were due to record, I woke up to watch Liza singing "New York, New York" on Rosie O'Donnell's talk show. I met her at the recording studio an hour or so later. She arrived still in full makeup, looking fabulous. I looked a little hungover and as though I'd just got out of bed (I had). There was some press there to record this historic event, and as we shared a cigarette in the fire escape before our first interview Liza said to me, "Darling, what is all this *for*? And do we get paid?"

I told her no, there was no cash, but it was in aid of Broadway Cares/Equity Fights Aids, and also the Twin Towers Fund. Minutes later, Liza was holding forth in front of the cameras talking of the work the charities had done (including statistics) and her anger over the recent events of September 11. She even burst into "New York, New York" again to wrap things up. I held her hand and said not very much except the

occasional "Hmm-mm," and when someone saw the piece on *Entertainment Tonight* they said I looked like a ventriloquist's dummy sitting on her knee.

But that is Liza, unsure of what is going on one minute, giving a press conference to several major TV shows with great élan the next; saying she never wants the pressure of performing again one month, the next stealing the show at Michael Jackson's concert at Madison Square Garden.

But the biggest contradiction of all was this: Once I went to a very subdued birthday party in Liza's hospital room. She was about to go into surgery for a second hip replacement, having recently recovered from her "death thing" as she referred to a particularly nasty bout of encephalitis. It was a strange night—Liza joking and laughing and saying it was the best birthday she'd ever had, and me saying how she must have planned to get ill just to have the view from the hospital room as the venue for her party. When we were alone, we joked about how we could procure her hip bone after the operation, sell it on eBay, and go shopping. Then I asked her how she was really feeling. "Scared, Alan. I'm really, really scared."

Cut to six months later. Liza is dancing every day, she had lost more weight than she probably once weighed. She was singing at the Garden, on *The Rosie O'Donnell Show*, on a record with me, and oh yes, shortly after she was getting married in St. Patrick's Cathedral, walking down the aisle as Natalie Cole, ah yes, actually her, sang "Unforgettable." Of course, none of us could have imagined just how unforgettable—for all the wrong reasons—this union would be. Still, you can't fault a girl for trying.

Liza and I have come from very different backgrounds but I think we recognize a kindred spirit in each other. We are an oddball pair, but onstage we have an amazing chemistry, I think because we are both open and prepared to be vulnerable

and people can see that we genuinely really love each other. But maybe there's something more than that . . .

In 1999, at the party after her first night of *Minnelli on Minnelli* at the Palace Theatre in New York, I was having a drink with my date wondering if I'd actually get a chance to speak to Liza. Those first-night parties are always insane, always still work, and the stars' time is never their known, and also our friendship was relatively new at the time. I looked across the room and saw a sort of human whirlpool approaching. It was Liza, being encircled by a constant stream of admirers and well-wishers, all wanting to tell her how happy they'd been to be present at such a legendary night. Each one was thanked and touched and spat out back into the shallows of the party, happy to have been in her glow for just a second. For Liza was not stopping to bask in their glory, she was on the move, she was looking . . . for *me*!

Finally the whirlpool abated and I realized it was because I was inside it, with her. "Oh Alan, there you are!" she gurgled, and kissed me. "I was thinking about you so much during the show tonight!"

"You were, Liza? Really?!" I said, incredulous, and also thinking she'd probably had enough on her plate what with the pressure of opening yet another comeback show without her mind wandering to little old me.

"Oh yes," she went on. "Well, I think we know each other from a previous life, don't you?"

I was stunned, and also kind of honored, yet very speechless, all at the same time. How do you respond in this situation?

"Maybe," I eventually stammered. "I hope so!"

Some flash bulbs went off; Liza kissed me, whispered, "Call me," into my ear, and she was off.

This picture just begged to be taken.

Liza had a birthday party at her apartment and everyone sang a song round the piano. It was one of those nights when I felt I was living in the movie of my life at the same time as actually living the real thing. Being around Liza kind of always feels like that, though.

Then there was a cake with this mini Liza on the top of it. Perhaps due to sugar high or cake lust, someone knocked her off and she fell amid the monogrammed cupcakes, a little dented but still sparkly and with arms open to life—just like the real-life Liza herself.

ONCE I MADE a film with Sylvester Stallone. He told me he took sixty vitamin pills a day, and he chided Woody Allen for not having plastic surgery. I liked him.

One night we were shooting in a forest. His character had taken me into the woods and threatened to kill me in order to get me to confess to something that I didn't do. I cried a lot and there was a lot of snot continuity to contend with.

Sly pretended to push me around and, as my hands were tied behind my back, I kept banging myself into various trees and stumps as I threw myself around, despite the fact that the forest floor was springy from all the fallen pine needles.

In between setups we sat in chairs with our names along the back and sipped cups of tea in polystyrene cups the PAs brought us. I wiggled my shoulder around and rubbed the back of my head where a nice egg-sized bump was forming.

"Gosh, I really hurt myself that time," I murmured.

Sly, neither missing a beat nor looking up from the newspaper he was perusing, said, "Welcome to action movies."

My heart skipped several beats. I felt I had been anointed into a sacred sect by the swami himself.

I ONCE SANG AT
THE HOLLYWOOD BOWL

WELL, I ACTUALLY sang there three times, but the same songs each night.

The Bowl has a summer concert series where they invite a random selection of celebrity musical types to sing a few numbers with the Los Angeles Philharmonic for three nights over a weekend. Eighteen thousand people come along and picnic and listen, and then much to everyone's delight (and my relief), they let off a load of fireworks and the night is done.

That was in 1999. I had a phobia about singing in public in those days. The fact that I had just finished a yearlong run of *Cabaret* on Broadway might make that phobia seem rather perverse, but let me explain . . .

I had always sung a bit. Early on in my career, as the latter part of the comedy duo Victor and Barry, I had sung plenty—the whole Victor-and-Barry setup was two men, a piano, funny chat, and a lot of songs that my friend Forbes and I had written. We'd made an album, and we'd toured all over the place. Later I sang in some plays and bits and pieces, and then came *Cabaret*, first in London and then in New York City.

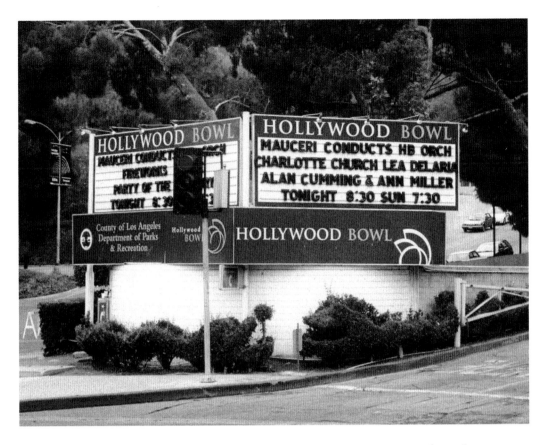

It was there that it all began. You have to remember that the musical is an American medium, in that Americans sort of invented it and they do it best. So, suddenly being flung into the middle of the Broadway scene and being a leading actor in the hit musical of the season meant that I was perceived in a way that I had hitherto never countenanced: I was in musicals therefore I could sing therefore I could be asked to come along and sing a few numbers at a gala and I would be great. Not.

For me, singing was always what a character did. *I* wasn't doing it. The confidence I had in using my voice in this way was manufactured by the fact that I was never, ever singing as *me*. So to be viewed as someone who had the moxie, let alone the ability (or even just the plain knowledge of songs from

any musicals!) to stand up anywhere and burst into song at the drop of a hat was a little galling. I felt like a fraud. I was an actor who sang a bit, who had been plucked from London and dropped conveniently in the middle of New York City's Theater District to be wicked and provocative and, yes, sing a bit. But it was always the Emcee doing the singing, never Alan.

But I always *yearned* to be able to sing as myself. In fact I think it's one of the few things I have ever yearned for in my whole life. I am not a yearner per se. I actually think it is a counterproductive thing. When you're so busy yearning for something you might one day do in the future, you miss out on all the real possibilities of the present.

But yearn I did. I think because I could tell there was an extra-special connection with the audience that came with revealing *you*, and I wanted to experience it.

If, like me, you believe being an artist is all about connecting with people, affecting them, and provoking them, then surely the most effective way to do so is with utter authenticity and no artifice. Being you. That felt like the most pure and simplest thing, but also the most daunting. Up till then, performing had been something that I felt I pulled on top of myself, like a costume. Now here I was considering stripping down to nothing, and I wasn't trained or ready to get naked yet.

So I did what I always do in these sorts of situations, and I dived in. I was asked to sing at the Hollywood Bowl and I said yes. It was many months off and it was only three songs and I knew the conductor, John Mauceri, from years ago when he used to run Scottish Opera and I wasn't topping the bill and it was all going to be okay.

Of course, it turned out to be the most terrifying thing I'd ever done, at that point in time at any rate. I had rarely performed to audiences of eighteen hundred, let alone eighteen

thousand. I had never sung with a symphony orchestra. I had never sung any of the three songs I was to sing in public before.

But it was an incredible experience for me and I learned a massive lesson: I'm not a singer who has one of those mellifluous, beautiful, otherworldly kinds of voices. My voice is okay. It's quite nice, actually. But what I'm really good at is interpreting a song—*acting* it. It was Rob Marshall, who'd just co-directed and choreographed *Cabaret*, and whom I was working with at the time on the TV movie of *Annie*, who enabled my epiphany.

When I confessed to him after one of the Bowl shows that I was having such trouble finding my feet with the notion of singing as myself, of being myself, or a version of myself on stage, he said, "Alan, you have to remember, you're a star. They want to hear you. People want to look at you. They just do!"

Now, that last section was very difficult to even write because I find it so incredibly difficult to countenance the concept of being a star. To me, I am an actor. Any sort of *stardom* has been a by-product of my work. But I understood what Rob was saying, and I understood what he was doing. It was the most loving bitch slap I've ever had. If I was going to stand up in front of thousands of people and sing someone else's words, I had to quit all the crap, get over myself, and admit there must be a reason why people want to hear me. So I did! And now I sing all the time. I do *concert tours*. I've sung at the Sydney Opera House, at Carnegie Hall, I've released albums! I could actually make my living entirely from singing if I wanted. And if I hadn't accepted that crazy offer of singing at the Hollywood Bowl, I might never have done any of those things, and I'd still be that person sweating and mumbling to himself at the side of the stage at some gala he'd been emotionally blackmailed into doing for a friend.

Another thing I'd never have done was get to know someone who really WAS a star: Ann Miller. I'd seen Ann in old MGM musical films like *On the Town* and *Easter Parade* and was really intrigued to meet her. At this point she was seventy-six but had just made *Mulholland Drive* with David Lynch, so she was very much alive and still kicking.

We first chatted at lunch after the initial sing-through at John the musical director's house. She knew I was a dear friend of Matthew Bourne, the brilliant English choreographer, who had recently toured his *Swan Lake* to America and had met many of his dance idols, including Ann, when the show played the Ahmanson Theatre in downtown LA. As we sat down I was a little shocked to see that her head was hovering just above the surface of the table. I worried that she had either dropped to her knees or placed her chair in some sort of hole in the restaurant patio. When I asked her if she was okay and could I help move her seat to higher ground, she laughed and said in that old-school-broad kind of way, "Oh, honey, you're sweet, but don't you worry! It's my legs. Everybody thinks I've shrunk when I sit down. I've got dancer's legs! They go on forevuh!"

And it was true! Her legs were insanely long. They practically started at her sternum. It was actually a bit disturbing once you noticed.

Each night before the show I'd nip into her dressing room and have a good old chinwag. Ann, I discovered, was quite bawdy and loved to dish the dirty (though never really the dirt) on her old days as queen of the Hollywood musicals. But she also talked fondly of her recent trip "back east" to play Carlotta in Stephen Sondheim's *Follies* at the Paper Mill Playhouse in New Jersey. In fact, she sang Carlotta's big number "I'm Still Here" as part of the Bowl show and, not surprisingly, brought the house down.

One night, as I was leaving her room to go and get ready, she called after me in her quavery yet booming voice.

"Alan, I've been meaning to tell you, I loved you in *Eyes Wide Shut*!"

I stopped in my tracks. I did indeed have a small role in Stanley Kubrick's last opus, which had just come out that summer, but I didn't think it was the kind of film a septuagenarian MGM musical star would rush to see. She was full of surprises.

"Really, Ann?"

"Oh yes, honey. I thought you were the best thing in the movie." She beamed at me encouragingly.

"But, Ann, I'm only in one little scene, so if you thought I was the best thing in it, does that mean you didn't *really* like the film?" I asked.

She considered this for a second, then, without missing a beat and like the vaudeville star she once was, retorted, "Well, I'd like to see the European version, because I hear there's more pussy in it!"

JET LAG

A FEW YEARS AGO I took my mum on a cruise across the Atlantic aboard the *Queen Mary 2*. I had been in Los Angeles for a while shooting the film *Any Day Now* then flew to the UK and got on the ship, so now was sailing back through a different time zone every other day and my body clock was in utter turmoil.

On the morning I took this picture I was wide awake at 4:00 a.m., so I got up and started to wander around the ship alone. It was magical. No one, but no one, was around. I walked through the ballrooms, their chandeliers clinking as the boat gently pitched through the early morning Atlantic swell.

I felt like a cat burglar, creeping through the restaurants and bars, even down to the lower decks where the crew slept. I saw absolutely nobody.

I felt like I had chanced upon the *Marie Celeste* yet I myself was a passenger, and then I came upon this abandoned jigsaw puzzle and knew I had found the perfect visual embodiment of my experience.

I went back to my cabin sleepy but happy. Sometimes jet lag is wonderful because it lets you see life as you never normally could.

FIRST CLASS DREAM

Seriously, if I was flying first class,
this would be my dream.

AWARDS

WHEN I FIRST WENT to Los Angeles, I found it all very daunting. I actually still do. I suppose the biggest problem is that it's not really a city, at least not in the way I think of how a city functions. It's really lots of suburbs. It has a downtown, but nobody showbizzy actually works there so it remains a sort of Oz-like mystery on the horizon.

It's a very disassociating city, but the thing I've come to learn about LA is that you have to stop feeling as though you're missing the party and accept that there isn't going to be any party unless you make it yourself.

Except, of course, when awards season comes around. Then you can't bend over to tie your shoelace without tripping over a party. The picture on the right is of Ruth Wilson, taken very late, at an after-party at the Chateau Marmont for the Golden Globe Awards in 2015. Ruth had won a Globe for *The Affair*. I had not for *The Good Wife*. She let me have a fondle of hers to make up for it, then tucked it back under her arm so she could continue drinking.

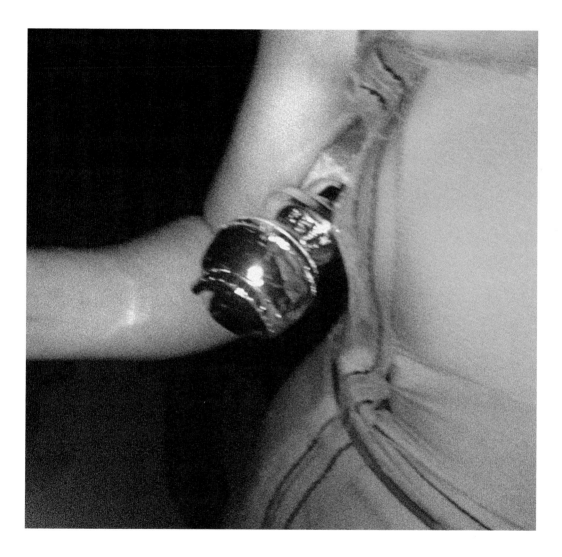

The pinnacle of awards season is, of course, the Oscars. Oscar time to Hollywood is like Christmas to the rest of us. People who normally don't exchange two words to each other all year gather together in uncomfortable clothes and new hairdos—and often, new faces—to share spirits and good will. Though instead of around a Christmas tree, in LA it's more likely to be around the boarded-over swimming pool of Hollywood's latest designated chichi hotel or an elaborate, cavernous series of opulent tents erected over what is usually a parking lot.

Where I grew up, the only awards ceremony parties I ever knew were sausage sizzles after the presentation of proficiency badges to the local Cub Scouts, and I always thought—correctly as it transpires—that the Academy Awards hullabaloo would be a bit too surreal for me to handle. However, once you've done a few Oscar weekends, it's like falling off a bike.

Just like the first time having sex or the first death of anyone close to you, popping my Academy Awards cherry is something I will never forget. It was in 2002. I was in town shooting a pilot for a TV series (that was never picked up) and so was invited along and initiated in the bizarre rituals of Oscar weekend.

First of all, I will attempt to paint a picture for you of what we are dealing with here. Imagine a little neighborhood near you being suddenly invaded for a few days by a group of, say, travel agents on a yearly work outing. Except instead of travel agents, think famous people, and think every living famous person you have ever known (and even some you thought were no longer living). What it boils down to is a famous people's *convention*, all of them emerging from the safety of their gated homes blinking and uneasy, bereft of the customary buffering of a publicist or assistant, and having to partake in the no-doubt leveling but utterly unusual experience of attending

a series of parties where everyone else in the room is as famous as they are. Can you imagine?

Oscar night, or Christmas Day if you will, is on Sunday, and in the week preceding, a series of lavish parties is thrown by the big studios, the big designers, and the big magazines. Think of these as rehearsals for the main event—a chance for celebs to practice walking, eating, drinking, and pressing the flesh with others of their breed who are equally unused to such complicated social interactions. By Friday, the town is buzzing with who is here, where they were, where they are going, and, most importantly, what they are going to wear.

That year, the ceremony was staged for the first time in the then-spanking-new Kodak Theatre on Hollywood Boulevard ("Oscar has come home" was a popular sound bite) instead of the hellish-to-get-to, way-way-downtown Shrine Auditorium or the Dorothy Chandler Pavilion. But the easier commute also brought with it a downside—the Kodak Theatre was much smaller, and a brutal selection process was initiated by the Academy to determine who was in and who was out. Never, even in this, the capital of faddiness, had the Hollywood food chain been so mercilessly displayed. And as if that weren't enough for a fragile celebrity ego to bear, a mood of restraint was pervading the normally opulent party scene, both in respect for the recent tragedies of September 11 as well as a clenching of the purse strings due to the prevailing recession, and that meant that some of the standard Oscar-week shindigs were being scaled down or cancelled entirely, leaving many regulars with the prospect of watching the whole thing from their living rooms, with only a cup of nonfat cocoa to look forward to as their aftershow drink of choice. And no goodie bags. Can you imagine?

There was one Oscar tradition, though, that never buckled, either to terrorist attack or financial fluctuation, and

that was the party thrown by the now late and lamented Ed Limato, the Daddy of International Creative Management, at his Beverly Hills *schloss*. And this was where it all started to get surreal for me. Firstly, I was pushed off balance by a woman in her eagerness to get onto the dance floor, and was further thrown by the realization that the shover was none other than Diana Ross AND that the song she was so desperate to dance to was *one of her own*! Talk about being in the middle of a chain reaction.

As I watched Elton John chatting with Shirley MacLaine by the buffet table, I was reminded again of Christmas, and of distant aunts and uncles making small talk while the children (and in this case Aunt Diana) jigged merrily nearby. And just as at family gatherings gossip and intergenerational advice are passed back and forth, so it was at Ed's party that I found out that the best way to deal with ludicrously uncomfortable high-heeled ladies' shoes is to throw them in the ice box for a few hours, so when you put them on and hit the red carpet, your bunions will be numbed and your feet will never swell. On returning home there is, of course, the slight risk that reaching into said ice box for a nightcap of Ketel One will result in impalement by a pair of forgotten Manolo Blahniks, but I think it is worth it, don't you?

The next day at the Independent Spirit Awards (a kind of anti-Oscars that kind of celebrate kind of non-studio films and feel a bit like naughty children having a garage party and cocking a snook at their parents' excesses, kind of), I made another discovery, that I had inadvertently joined a secret Hollywood coven and was bound to so many others by a secret that dare not speak its name: hair extensions. I had them put in for the TV pilot, and my sudden mane of sleek shoulder-length hair was the source of a lot of speculation as well

as illicit confession from Hollywood's finest that they too did not rely totally on what God gave them. Kate Beckinsale and Christina Ricci both fingered my proffered roots knowingly, feeling the little nubs of plastic at my scalp and motioning to their own. And get this, the lady who put mine in (it took *eleven* hours—that's more than twice the length of the Oscar ceremony, and many more times as mind-numbing) told me she had once done Sandra Bullock's. I now know the price Sandra pays for that girl-next-door demeanour.

However, later that night at the annual Miramax party and cabaret—think of your boss forcing you to perform sketches at your Christmas party in front of all your colleagues, then think your boss is Harvey Weinstein and you are Neve Campbell or Uma Thurman and your colleagues are everyone who has been in a Hollywood film in the last ten years—my new extensions held no sway with the security men, worried that the over-capacity throngs who were reveling atop the Skybar's covered pool were about to gain the attention of the fire marshals in attendance and shut the whole thing down. Can you imagine?

I was saved, however, by the appearance of Sharon Stone, her then husband, and an elderly couple who I first thought were agents I had met once but who I soon realized, as Sharon grabbed my hand and pulled me into the party, were elderly relations of hers.

"Hold on to them, Alan," Sharon shouted over the din. I think she said they were her step-grandparents or her in-laws or something, but all I know is that one of my hands was being gripped by Sharon Stone and the other was clasped to an older lady very precious to Sharon, and I must not let go. We were taken, amid the cacophony of the amplified onstage skits and the screaming drinkers, to a little curtain behind which the sketches were being prepared and where Harvey Weinstein,

then the boss of Miramax, was holding a clipboard and looking for all the world like a harried father desperately tying to control the backstage chaos at an end-of-term school concert. I didn't know what was going on. It was all too noisy and I was worried about losing the grip of Sharon's in-law or granny, and I can hear Sharon telling Harvey no, she doesn't feel comfortable taking part in a skit, and before I know it, she is gesturing toward me and then I feel Harvey's slightly lecherous glare at seeing fresh blood, and I am prized away from Granny, forced into a raincoat, given a trolley bag, a microphone, and a piece of paper and thrown onto the makeshift stage to portray Maggie Smith from *Gosford Park* in a sketch with Hugh Jackman as Ian McKellen in *Lord of the Rings*. Then it all starts to get very blurry. I had never met Hugh at that point in time, or indeed any of the other actors onstage with me. I had never read the lines I was reading before. I had no idea what was going on. I had been in the party perhaps ninety seconds. It doesn't get much more surreal than this.

Actually, I lied, it does. The next night I watched the televised Oscar ceremony at the *Vanity Fair* dinner. Joan Collins told me Barbra Streisand is terrified of cosmetic surgery and had had absolutely *nothing* done; Oprah and I chatted about the cultural implications of the Best Actor and Actress prizes going to African Americans; J-Lo told me how nervous she had been; Diana Ross pushed me aside on her way to the dance floor *again*; Maggie Smith asked me if I remembered having met her! (I didn't mention I had impersonated her the night before.) I ate cookies with Josh Hartnett's face on them, and I spent the moment of silence standing beside Jackie Collins, who hadn't been paying attention to the TV screens transmitting the ceremony and wondered (in a whisper, thank goodness) why everyone had stopped talking.

Sometime in the early hours, there was an electrical fault and the party was plunged into darkness. Everyone panicked that it was a terrorist attack. I was chatting to Glenn Close at the time and I remember having to quell an overpowering urge to goose her. It was time to go.

I braved the paparazzi, and miraculously found my driver. As I disappeared into the night, I had that familiar, bittersweet feeling of being relieved that Christmas comes but once a year.

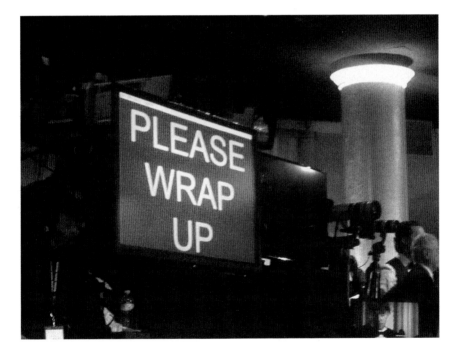

ACKNOWLEDGMENTS

THANKS MOSTLY to all my friends, loved ones and randoms who let me shoot them, knowingly or not. This book is a slice of the delicious pie that is my life and I am so grateful you are all ingredients. It wouldn't exist without the good humor and patience of Charles Miers, Anthony Petrillose, and Caitlin Leffel at Rizzoli, Richard Pandiscio and Bill Loccisano from Pandiscio Co., and my supermodel agent Luke Janklow. Thank you all for indulging my idiosyncratic methods and terminology. I am now fully versed in landscape and portrait! Finally much, much thanks for everything to Jimmy Wilson, my faithful assistant and hipster butler . . .

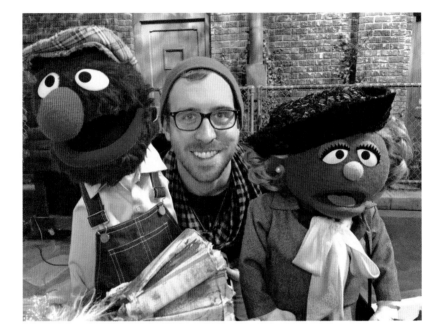

ABOUT THE AUTHOR

ALAN CUMMING is the author of two books: *Tommy's Tale: A Novel of Sex, Confusion, and Happy Endings* and the #1 *New York Times* best-selling memoir *Not My Father's Son*. He has also had an exhibition of his photographs, *Alan Cumming Snaps!* His day job is acting, and most recently he was seen on TV as Eli Gold in the CBS drama *The Good Wife*, on Broadway in his Tony Award–winning role as the Master of Ceremonies in *Cabaret*, and in concert, touring the world with his cabaret show, *Alan Cumming Sings Sappy Songs*, which was also released as a live album. Alan is also a loudmouth—sorry, activist—who believes that knowledge is power and equality is a right, not a privilege. To find out every single thing he's ever done, visit www.alancumming.com, and to find out what he's doing on a daily basis follow @alancumming on Twitter and @alancummingsnaps on Instagram.

FIRST PUBLISHED IN THE UNITED STATES OF AMERICA
IN 2016 BY:

Rizzoli International Publications, Inc.
300 Park Avenue South
New York, NY 10010
www.rizzoliusa.com

ISBN-13: 978-0-8478-4900-0
Library of Congress Control Number: 2016935021
© 2016 Rizzoli International Publications, Inc.
Text © 2016 Alan Cumming
Photographs © 2016 Alan Cumming
Endpaper illustrations by Grant Shaffer

For Rizzoli
CHARLES MIERS, Publisher
ANTHONY PETRILLOSE, Managing Editor
CAITLIN LEFFEL, Editor
GISELA AGUILAR, Editorial Assistance
ELIZABETH SMITH, Copy Editor
ALYN EVANS, Production Manager

For Pandiscio Co.
RICHARD PANDISCIO, Creative Director
WILLIAM LOCCISANO, Designer

All rights reserved.
No part of this publication may be reproduced, stored in a retrieval system,
or transmitted in any form or by any means, electronic, mechanical,
photocopying, recording, or otherwise, without prior consent of the publisher.

Distributed to the U.S. trade by Random House, New York
2016 2017 2018 2019 2020 / 10 9 8 7 6 5 4 3 2 1

Printed in China

31901059740300